The Slave Who Loved Caviar

A theatrical investigation into the relationship
between Jean–Michel Basquiat and Andy Warhol

Published in the United States by:
Archway Editions,
a division of powerHouse Cultural Entertainment, Inc.
32 Adams Street, Brooklyn, NY 11201

www.archwayeditions.us

Daniel Power, CEO
Chris Molnar, Editorial Director
Nicodemus Nicoludis, Managing Editor
Naomi Falk, Senior Editor
Caitlin Forst, Contributing Editor

Library of Congress Control Number: 2023927067

ISBN 978-1-64823-016-5

Printed by Toppan Leefung

First edition, 2023

10 9 8 7 6 5 4 3 2 1

Layout and design by Nicodemus Nicoludis
Proofreading by Arts Editing Services: Tyler Considine and Liz Janoff

Cover image: Lezley Saar, *Brainville*, 2016, acrylic on fabric, courtesy of the artist

Printed and bound in China

ARCHWAY
EDITIONS

The Slave Who Loved Caviar

Ishmael Reed

Archway Editions, Brooklyn, NY

CONTENTS

INTRODUCTION:

The Warhol Foundation's Basquiat and Mine

My play, *The Slave Who Loved Caviar*, challenged the perception promoted by the Manhattan art industry that painter Jean-Michel Basquiat was Andy Warhol's "mascot." Or that it was because of Warhol's beneficence that Basquiat, born of Haitian and Puerto Rican parents, became famous.

Warhol's reputation was declining when he began the collaboration, and according to some observers, Basquiat's "new blood" resurrected Warhol. Basquiat said that he did most of the work during the collaboration and that Warhol was "lazy."[1] Yet in *The Collaboration*, a play by Anthony McCarten and endorsed by the Warhol Foundation, Warhol and Basquiat are seen contributing equal amounts of work to the project. Basquiat knew what was happening to him. He said they viewed him as a "monkey man." But the critics who disparaged him were operating from a narrow Euro-American-centric frame of reference and were incapable of identifying some of the traditions that influenced him.

From the beginning, my play ran into trouble. The Warhol Foundation objected to a flyer that I created. In one of Basquiat's paintings, the words "parasite" and "leeches" are repeated. I took the top half of Warhol's portrait of Basquiat, where Basquiat poses like Michelangelo's *David* while wearing only a jockstrap, and inserted pictures of leeches on Basquiat's body. Inside each leech, I included a photo of Warhol.

Warhol benefitted from the collaboration in more ways than one. Basquiat got him to paint again, and he even charged Basquiat rent.

Was Basquiat thinking of the gallery owners, the hangers-on, and the intimates who exploited him when he invoked "parasites and leeches"? A girlfriend sold a refrigerator that Basquiat covered with his "doodles" to Christie's for $5,000. In *The Collaboration*, a character named Maya says she needs the money to pay for an abortion because Basquiat has impregnated her. Maya is based on one of Basquiat's girlfriends, Suzanne Mallouk.[2] In *Widow Basquiat: A Love Story* by Jennifer Clement, she says Mallouk sold the refrigerator, but she doesn't mention that it was to pay for an abortion. She says Mallouk says that she can't have children. Was this poetic license or the use of the old Black male corrupting white woman trope, which titillates audiences that can afford to buy theater tickets?

One of the "parasites" that Basquiat might have had in mind was Mary Boone. Though depicted as Basquiat's agent in *The Collaboration*, omitted from the play is Mary Boone's prison sentence for tax evasion as a result of extravagant spending on clothes and apartment improvements.

Ironically, the Warhol Foundation, which has millions at its disposal, threatened to sue me over my flyer because Warhol's career was founded on "transforming" the works of others. A lower court decided that his use of a poster made by Lynn Goldsmith of her 1981 photograph of the pop star Prince wasn't transformed enough and was a copyright infringement. When the Warhol Foundation appealed the case to the Supreme Court, their 7-2 vote also ruled that Warhol had infringed on Goldsmith's copyright.

So why couldn't I "transform" one of his works by incorporating it into a flyer? Warhol was constantly sued for plagiarism.

My play ran at Theater for the New City from December 23, 2021 to January 9, 2022. It played to healthy audiences and was scheduled to return to New York in December, but because the play refers to

Annina Nosei, who, according to witnesses, exploited Basquiat, Nosei threatened to sue. Basquiat said that he was her victim and that she sold paintings that weren't finished. His complaint appears in *The Jean-Michel Basquiat Reader*, edited by Jordana Moore Saggese.

Crystal Field, the producer at Theater for the New City, added that she and Nosei lived in the same building and were friends. She wrote:

Dear Ishmael,

> It is with a heavy heart that I have to tell you that I really cannot do *The Slave Who Loved Caviar*. I had no idea that my neighbor, who I know as Annina Weber, is the same person mentioned in your play. Also, I had always spelled her name with one N. I had never heard of Basquiat before your play, and I was not cognizant of the world of Andy Warhol. Annina Nosei is my neighbor and friend for over 30 yrs, she lived next door to me for a long time and I helped her with her English. It really is an Emotional conflict of interest so I must recuse myself.

Nosei's friend, Linda Yablonsky, did a hit job on my play in *The Art Newspaper* that was so excessively negative that she apologized.[4] As a result, the return engagement was canceled. All is not lost because we made a video of the play available to rent. Contact Ishmael Reed at ireedpub@yahoo.com.

Also, the African American Shakespeare Company will stream a videoed production of the play using a San Francisco based cast. L. Peter Callender will direct. In October 2022 Crystal Field produced four live virtual readings of my newest play, *The Conductor*, about how white nationalist tech billionaires cynically divide minorities in school board elections in San Francisco and elsewhere. A full

production was presented at the Off Broadway theater from March 9 to March 26, 2023, with a return three week engagement from August 24 to September 10, 2023.

The Warhol Foundation endorsed Anthony McCarten's play, *The Collaboration*, in which Warhol is a kind of male nurse to Basquiat, an irresponsible waif. In the play, Warhol attempts to civilize Basquiat to no avail. This script amounts to a cover-up, and the playwright Anthony McCarten has a kind of reputation as a cleaner for the powerful. He did the TV series *The Two Popes*, which sanitizes Pope Benedict, who sought to hush up the church's pedophilia scandal. McCarten also hosed down Churchill with his film *Darkest Hour*. Churchill's policies led to the starvation of millions in India.

My play depicts Warhol as a depraved and decadent leader of a death/suicide cult. He didn't care whether the young people he exploited lived or died, yet in McCarten's play, Warhol says to Basquiat: "Is that why your paintings are filled with so much death?" Warhol merchandized death. Car crashes. Executions. Andy Warhol appropriated a picture of Evelyn McHale's suicide for his *Suicide: (Fallen Body)* (1963). His response to the suicide of his actress Edie Sedgwick and that of dancer Freddie Herko was that he wished he'd been there to film their suicides.

When he received an urgent plea from one of those who truly cared for Basquiat, Paige Powell, that Basquiat's cocaine addiction had become life-threatening, Warhol quipped: "Maybe he wants to be the first to go out early." In *The Collaboration*, however, Warhol is portrayed as a naive, clean, churchgoing individual who cares about Basquiat's welfare:

> ANDY: Because Jean, you have to live. And I get it, you've
> already convinced the market you're gonna die soon
> from doing so much heroin, and nothing pushes up
> prices like the promise of early death, nothing. But

you don't have to do that, Jean. You can be great and live to see it.

Warhol found Basquiat disgusting. He called him "dirty" and regarded him as a nuisance. This and other negative views are published in *Warhol On Basquiat*, edited by Michael Dayton Hermann. Warhol's screenwriter Ronald Tavel thought Warhol lacked compassion. He said, "Sometimes I admit that his coldness was shocking. Some of his responses that he made to the deaths at the Factory I could not believe." Tavel tried to sue for payment for his screenwriting. Warhol's hiring of a fancy lawyer discouraged him.

In my play, *The Slave Who Loved Caviar*, I mention an incident in Italy where Warhol physically assaulted Basquiat because he was getting more attention than Warhol. Warhol boasted about the assault. While dwelling upon Basquiat's drug addiction, *The Collaboration* shows Warhol abstaining from drugs. Warhol was addicted to amphetamines.[5] The Warhol Foundation's play, *The Collaboration*, has an "Ebony and Ivory" ending:

> ANDY: But Jean you've already brought me back to life, which is super great because God's had it his own way for far too long. They look into each other's eyes.

> ANDY: Jean-Michel Basquiat…I order you to live forever… forever and ever. And with all that extra time you simply have to learn how to use a vacuum cleaner.

> JEAN: (*Laughing.*) I love you Andy.

> ANDY: Oh shut up and paint. Just paint. Or we'll never be finished. (*Curtain.*)

With the millions behind *The Collaboration*, the play and the movie will become a hit. The film marks the directorial debut of Kwame Kwei-Armah, with Paul Bettany playing the artist Andy Warhol and Jeremy Pope playing Jean-Michel Basquiat. According to Mike Fleming Jr.'s February 2022 Deadline report, "The film will go into production later this year with McCarten producing through his Muse of Fire Productions along with oft-producing Denis O'Sullivan."[5] Exploited while he was alive, the exploitation of Basquiat continues. People are making money from fake Basquiats.

And now this play and film.

The *New York Times*, which ignored my play, is building momentum for *The Collaboration*, but as Joe Louis said, "You Can Run But You Can't Hide." My play, *The Slave Who Loved Caviar*, will shadow *The Collaboration* just as my play, *The Haunting Of Lin-Manuel Miranda*, continues to shadow *Hamilton*, another megahit that redeems a person whose brand was cruelty.

[1] Jean-Michel Basquiat, *Basquiat-isms* (Princeton: Princeton University Press, 2019).

[2] Jennifer Clement, *Widow Basquiat: A Love Story* (New York: Broadway Books, 2014).

[3] Linda Yablonsky, "What really killed Basquiat? Playright Ishmael Reed has a theory," *The Art Newspaper*, January 28, 2022. https://www.theartnewspaper.com/2022/01/28/what-really-killed-basquiat-ishmael-reed-has-a-theory.

[4] John Giorno, *Great Demon Kings: A Memoir of Poetry, Sex, Art, Death, and Enlightenment* (New York: Farrar, Straus and Giroux, 2020).

[5] Mike Fleming Jr., "Anthony McCarten's Warhol-Basquiat Stage Play 'The Collaboration' Heading for Big Screen; Helmer Kwame Kwei-Armah, Paul Bettany & Jeremy Pope Reprise," *Deadline*, February 3, 2022. deadline.com/2022/02/warhol-basquiat-play-the-collaboration-movie-kwame-kwei-armah-paul-bettany-jeremy-pope-anthony-mccarten-1234926222/

The Slave Who Loved Caviar

Ishmael Reed

Ishmael Reed's tenth play, *The Slave Who Loved Caviar*, was first presented as a virtual reading on the Nuyorican Poets Café's platform in March 2021, directed by Rome Neal.

A full production was produced by the Off Broadway venue, Theater for the New City, in their Joyce and Seward Johnson Theater. Directed by Carla Blank, it premiered on December 23, 2021 and ran for three weeks, closing on January 9, 2022.

The performance included music composed and performed on piano by Ishmael Reed: "Tolls for Basquiat," "Barrelhouse Basquiat," "Hands of Grace," and "When Beautiful Boys Drown in the Nile They Become Gods."

ORIGINAL CAST, IN ORDER OF APPEARANCE

Jennifer Blue	Kenya Wilson
Agent Antonio Wolfe	Jesse Bueno
Baron De Whit	Raul Diaz
Detective Mary Van Helsing	Roz Fox
Forensic Expert I: Grace	Laura Robards
Forensic Expert II: Raksha	Monisha Shiva
Jack Brooks	Robert E. Turner
Young Blood	Brian Anthony Simmons
Voice of Richard Pryor	Maurice Carlton
Richard Pryor of the Dream shadow dancer	Kenya Wilson
Sleeping shadow image of Jean-Michel Basquiat	Raul Diaz

PRODUCTION

Set design	Mark Marcante and Lytza Colon
Lighting design	Alexander Bartenieff
Sound design	Alexander Bartenieff
Costume design	Diana Adelman
Props	Lytza Colon
Projection design	Miles Shebar
Stage Manager	Michael Durgavich
Assistant Stage Manager	Juan Carlos Augustin
Light/Sound Board Operator	Brian Park
Production Coordinator	Rome Neal
Director and choreographer	Carla Blank
Playwright	Ishmael Reed
Piano compositions and performance	Ishmael Reed

CHARACTERS, IN ORDER OF APPEARANCE

Jennifer Blue: Woman between twenty-five and thirty years old. Victim of the Baron.

Antonio Wolfe: Middle-aged man. The Baron's agent, a longtime associate of the Baron.

Mary Van Helsing: Middle-aged Black woman. Chief of Detectives, New York Police Department.

Baron De Whit: Middle-aged man who is the son of Dracula.

Forensic Expert I: Grace.

Forensic Expert II: Raksha.

Jack Brooks: Homeless Black male. Abstract Expressionist painter, about sixty to seventy-five years old.

Young Blood: Graffiti artist. Black male, about twenty-eight years old.

Richard Pryor of the Dream: Black male. In the Theater for the New City production, this character was performed with a voice-over, visualized by a shadow play, which included a sleeping Basquiat-like figure and a dancer moving as Richard Pryor.

ACT 1, SCENE 1

On stage: Millennial, JENNIFER BLUE *is talking to a friend on her cellphone. She is dressed in a costume of Cinderella as a housemaid, in a Caribbean-style update on the classic Disney character. Wears a half mask that covers her eyes. There is a dab of cinder on her cheek.*

Light cue: Monologue special up.

JENNIFER: (*With Cinderella mask.*) I can't have a Halloween party with the girls tonight. . . No, it's not homework, are you ready for this? Are you sitting down? (*Excitedly.*) I've been invited to Baron De Whit's Halloween party, the social event of the year. Don't you remember, he came to the poetry slam at the Nuyorican Poets Café. He says that he couldn't take his eyes off of me. He especially complimented me on my lovely throat. He says that he wants to include me in a performance piece. Isn't that thrilling? (*Jumps up and down. Squeals.*) He didn't give any details about the piece. Just that for rehearsals I'd have to become used to sleeping in cramped quarters during the day. For authenticity. What is my costume tonight? I'm going to dress like Cinderella in the Disney movie. Everybody is required to wear a mask. Isn't that just so intriguing. What about Ricky? Just tell Ricky that I'm studying tonight. He's so immature. While the Baron is suave and charming. He's from Europe, you know. Lived in one of those castles that you see in the Viking Cruise ads. Besides, Ricky isn't really my boyfriend. We only dated a couple of times. He is as exciting as a raisin. Look, I got to go. Ciao.

Light cue: Lights fade out on JENNIFER BLUE. *Lights up on shadow screen for the passage of* BARON DE WHIT *and* AGENT ANTONIO WOLFE *to the* BARON'S *house, with sound cue: Rain. Thunder.*

Shadow screen lights out once the BARON *and* WOLFE *are in place in the library. Followed by lights up on the* BARON'S *library.*

ACT 1, SCENE 2

BARON's *library. The* BARON *is seated in an elegant chair. He is dressed in a black tuxedo and cape with red lining. On the wall, over the fireplace, is a painting of Bridget, Mother of the Dead.*

Sound cue: Rain. Thunder continues. A knock on the door.

The BARON *drinks from a glass filled with a red liquid substance.*

AGENT ANTONIO WOLFE *appears.*

AGENT WOLFE: (*Heavy movie Transylvanian accent.*) A detective is outside. She wants to speak with you.

BARON: (*Heavy movie Transylvanian accent.*) A detective. Why would a detective want to speak with me?

AGENT WOLFE: Want me to get rid of her?

BARON: No, that would only arouse suspicion. (*Hides glass of blood.*) Send her in.

AGENT WOLFE *exits. Enter* DETECTIVE MARY VAN HELSING.

BARON: And who may you be?

MARY VAN HELSING: Mary Van Helsing. Chief of Detectives, NYPD. (*Shows badge.*)

BARON: (*Rising, approaching her.*) And what have I done to deserve the presence of your company.

BARON *tries to kiss* DETECTIVE MARY VAN HELSING's *hand. She pushes his hand away.*

MARY VAN HELSING: Cut the bullshit, Baron. This is not a social call. I'm going to show you some pictures. (*Shows* BARON *a photo of* JENNIFER BLUE.) Do you recognize this girl? Her name is Jennifer Blue.

BARON: (*Inspects the photo.*) I'm sorry Detective Van Helsing. I've never seen this girl in my life.

MARY VAN HELSING: She was last seen at your Halloween party. Her roommate says that you invited her. That you wanted her to appear in a performance piece.

BARON: All of my guests were wearing masks. How could I tell them apart? Besides, I'm always inviting young people to participate in my work. Whether they be models or performers. They have to get their start somewhere.

MARY VAN HELSING: But you must have a guest list. Her name might appear there.

BARON: (*Snobbishly.*) We shred those lists as soon as a particular party is over. Our guests come from the rarefied regions of New York society. They insist upon our discretion.

MARY VAN HELSING: She was dressed like Cinderella in one of the Disney movies, according to her roommate. You must have seen her.

AGENT WOLFE: (*Enters.*) Baron, the car is waiting to take us to see *Hamilton.*

AGENT ANTONIO WOLFE *exits. Shortly thereafter reappearing as he peeks through a crack in the library's door.*

BARON: Unfortunately, Detective, I have to leave; I have to end this interview.

DETECTIVE MARY VAN HELSING *starts to leave but turns around.*

MARY VAN HELSING: By the way, the Bavarian government said that you were delinquent in paying property taxes on your castle. That it was overrun with rats. When they opened the door, the odor was so foul that several members of the police force fainted. They're sending investigators, and we've offered them our full cooperation.

BARON: Let them come. I have nothing to hide.

MARY VAN HELSING: You sure? Well, if you hear anything, here's my card.

DETECTIVE MARY VAN HELSING *hands the* BARON *her calling card and exits.* ANTONIO WOLFE *reenters.*

BARON: What do you think she knows?

AGENT WOLFE: Somebody must have tipped her off.

BARON: She's onto something. I can tell. The way she looked at me. As though she could see right through me.

AGENT WOLFE: Think that she has the gift?

BARON: I can call off an investigation if she gets too close. You know the people who attend our parties are well connected, some of the most important players in this town. Governors, captains of social media, generals and college presidents, European royalty. They like their women real, real young. I have all of their names in my black book. If I go down, they go down with me.

AGENT WOLFE: You're the most feared man in town. Nobody has the nerve to cross you, in a manner of speaking.

Light cue: They laugh as stage light out to dark. Followed by spot up on FORENSIC EXPERT I: GRACE.

Sound cue up: "Tolls for Basquiat."

Act 1, Scene 3

FORENSIC EXPERT I: GRACE: (*Removes notes from a satchel. Begins to read from clipboard.*) Those who monopolize the framing of Jean-Michel Basquiat's career might regard him as a pest, a mascot or a primitive, or a drug-crazed, coked-up maniac.

Projection up: Coked-up, manic Basquiat image from graphic novel, Basquiat.

He was defamed as a street urchin, a bum, and a leech. But Basquiat was not only a painter but a filmmaker and musician whose life was the subject of a biopic. According to the New York art crowd, Basquiat's career was made when he began a collaboration with Andy Warhol.

Projection out: Graphic novel, Basquiat.

However, Bruno Bischofberger, an art dealer, says that in the '80s Warhol normally sold nothing: "Not a single painting of his dollar sign show (held at the Leo Castelli Gallery in 1982) was sold. (*Enter* FORENSIC EXPERT II: RAKSHA.) The same thing happened when the show traveled to Paris."

Sound cue out: "Tolls for Basquiat."

FORENSIC EXPERT II: RAKSHA: Grace, what are you reading?

GRACE: Going over my notes. Detective Van Helsing wants them soon.

RAKSHA: This is a waste of time. She's obsessed with this Jean-Michel Basquiat. His paintings are just a bunch of scribbles and the faces of angry Black men.

GRACE: Raksha, I've been here longer than you. Chief of Detectives Van Helsing is no one to be messed with. She worked her way up through the ranks and survived every test that these pigs hurled at her. She promised Hilda Owen that she'd pursue her theory that Basquiat was a victim of foul play.

RAKSHA: Hilda Owen? Who was that?

GRACE: She was a detective back there in the 1980s.

RAKSHA: A woman detective in the 1980s?

GRACE: You can imagine the shit that she had to take. Her male colleagues resented her. Some refused to even work with her. There was constant harassment. Jokes. The NYPD has changed since then.

RAKSHA: Not all that much.

GRACE: Look at it this way, Raksha. Now we have gay officers. The Gay Officers Action League.

RAKSHA: Yes, but the gay pride community doesn't recognize them. They have banned them from marching in the Pride parade.

GRACE: That's how Basquiat felt about Black officers. He caricatured them. In 1981, he painted *Irony of a Negro Policeman*. Then there's *Sheriff*, which ridicules an officer by using distortion. But

I think that it's better for some cops of color to be on the inside than on the outside looking in. They can intervene when their colleagues are over-policing.

RAKSHA: Tell that to Carol Holloman Horne, a Buffalo police officer. She intervened in an arrest where she said a fellow officer used a choke hold on a handcuffed suspect.

GRACE: What happened to her?

RAKSHA: The officer punched her. She was fired and she lost her pension. But this year a judge ruled in her favor and her pension was restored, but look at all of the trouble they put her through. That's what she got for working on the inside. Sometimes working on the inside of institutions that are intractable, like the police force, can lead to misery and frustration. We even get it on our job in forensics.

Sound cue in: "Tolls for Basquiat."

GRACE: Good point. Some say that Basquiat would have survived if he had remained on the outside. Selling postcards.

Projection in: A Series: Art History.

Expressing himself by painting on walls. Even on a refrigerator. I think the evidence shows his becoming part of the Warhol cult is what killed him. Though most of the writers, fans of Warhol, say that his death was self-inflicted, an argument could be made that he was an innocent lured into a death cult in which Warhol, according to art-world documentarian Emile de Antonio, was the Angel of Death's apprentice. Warhol even called himself

"undertaker" at one point. There seems to be a consensus among pro-Warhol White critics that Basquiat was dependent upon Warhol.

Projection out: A Series: Art History.

RAKSHA: Depends upon who controls the story about the two, doesn't it. Story ownership has been a question throughout world history. My grandmother used to say, "Beta, until the lion tells the story, the hunter will always be the hero."

GRACE: Bugs and maggots are our storytellers.

RAKSHA: I heard that.

GRACE: Was Basquiat the lion and the all-White art critics' establishment the hunter?

RAKSHA: Basquiat addressed that. He said: "I think I helped Andy more than Andy helped me." If one is familiar with the style of both, a cursory glance at the "collaboration" indicates that Basquiat did most of the work. I'm not a fan of either, nor am I an art historian, but I can see that.

GRACE: Between the two, the critics favored Warhol because Warhol was famous.

RAKSHA: And White. Don't forget that part—

GRACE: Okay, I grant you that. But another reason might be that while Basquiat was a serious painter, Warhol represented a trend that was moving away from painting. He once said that painting

was dead. He concentrated on stunts which involved brand names, like creating facsimiles of Brillo boxes and passing them off as art in museums. He spent a lot of time in grocery stores. (*Reads from clipboard.*) David Bowie might have made the most profound comment about Warhol's art: that as a Byzantine Greek Catholic, "he was fascinated by icons." If the Byzantine was his spiritual home, the department store was his secular home. He dressed mannequins. He had the soul of a mannequin. Though he had a downtown address, he was Madison Avenue through and through. He was at heart an advertiser. He never denied that he was a commercial artist. What have you found?

RAKSHA: (*Looks at notes.*) Well, listen to this. Ultra Violet, the late Warhol actress, seems to agree with you. She was an intimate. She says, "He learned all about screens and multiples and blow-ups and colorization in his days as a commercial artist." And listen to this. (*Reads from clipboard.*) Among the icons created by Warhol was Count Dracula. He produced a film called *Young Dracula*. His nickname was Drella. A cross between Dracula and Cinderella. Did Warhol get the nickname Drella because, after sucking energy from his followers, they became the living dead? And why Cinderella? Was it because he got turned on by the central image in the Cinderella myth—the shoe? In the first Cinderella story, a bird drops a sandal in the presence of an Egyptian king. The King sends out his men to find the owner of the shoe. She's a slave. Found, she marries the king. And so, the story evolves over the centuries until the sandal becomes a glass slipper.

Sound cue out: "Tolls for Basquiat."

John Giorno writes of Warhol: "He had a secret reputation as a shoe fetishist; for years he'd designed shoe ads for Bergdorf Goodman, I. Miller, and Bonwit Teller. There was Andy Warhol on his hands and knees, licking my Abercrombie & Fitch loafers. He wiggled his tongue around and smelled. My shoes were covered with saliva. It was a turn-on."

GRACE: (*Holds her arms. Shivers.*) OOOOO. That's creepy. Basquiat was hanging out with this guy? This Warhol was a sick puppy! Do you think that Warhol might have masturbated when he saw Basquiat on the cover of the *New York Times Magazine*, shoeless?

RAKSHA: Gross. Do you have to go there?

GRACE: Gross? All of the crime scenes we've had to examine. You didn't seem squeamish when all that was left of a victim were some messy body parts. And you get offended when I use a word like "masturbation."

RAKSHA: I'm not prepared for a case like this. There is no blood, no saliva, no drinking glasses or cigarette butts with DNA traces, no—

GRACE: Look at it this way. There's metaphorical blood.

Sound cue in: "Tolls for Basquiat."

Critics said that Basquiat gave Warhol "new blood." Warhol was called a "leech," so dependent was he upon Basquiat. In one of his paintings, Basquiat wrote the words "leech" and "parasite." Basquiat knew that he was being used. He was just a kid, but he knew that much.

RAKSHA: You got the Dracula part of Warhol down. What about the Cinderella part? You have any ideas about that?

GRACE: (*Read from clipboard.*) Sigmund Freud's Cinderella has some of the qualities that have been attributed to Warhol, "Vain, selfish, immature, and power-hungry." The Marxist Cinderella is exploited, but she, in turn, exploits mice, birds, and a fairy godmother. Like those who worked for Warhol, including Basquiat, they were either unpaid or underpaid. Warhol studied his subjects obsessively. One of his most famous films showed poet John Giorno asleep. For eight hours.

RAKSHA: You mean people paid some good bucks to see a man asleep for eight hours?

GRACE: He also did a film called *Empire*, which just showed the Empire State Building, also for eight hours. He saw the building as a mighty hard-on. He got a different response, however. People heckled, booed, and threw things at the screen. Warhol said the art was in how the audience reacted.

Sound cue out: "Tolls for Basquiat."

RAKSHA: Metaphorical blood. Grace, you always have to go egghead on me. I forgot that you were a classics major before you got into forensics. Why did you quit the classics?

GRACE: In this age of The Woke, today's students just see Greek and Roman myths as one of many of the world's storytelling traditions. They barely cover the storytelling traditions of Europe. Every tribe has its odyssey. Enrollment is down and so I would have starved if I had become a classics professor. I'm not

the starving kind. What about you? What drew you to forensics?

RAKSHA: My folks wanted me to become a doctor. Not a chance. I grew up watching *CSI*. It had to be forensics.

GRACE: The Indian community is to be admired. Your people are devoted to hard work.

RAKSHA: That may be true, but White people still call us niggers.

Light cues: Spot out on FORENSIC EXPERTS. *Light up on shadow screen for second cross by* BARON *and* AGENT ANTONIO WOLFE. *Once in place, lights out on the shadow screen and up on the* BARON'S *library.*

ACT 1, SCENE 4

The BARON's *library.* AGENT ANTONIO WOLFE *and* BARON DE WHIT *in conversation.*

AGENT WOLFE: I'm sorry Baron, but there were no bids on your work at Sotheby's. These days they can't even sell French Impressionism. The Masters.

BARON: What's happening? My last drawing, *Mother of the Dead*, sold for $2 million.

Projection in: Bridget, Mother of the Dead.

BARON *gazes at painting above the mantelpiece while* AGENT WOLFE *confides to audience.*

AGENT WOLFE: (*To audience.*) He's been doing the same painting ever since he got a crush on this redhead they call *Mother of the Dead*. He could never have her because she belonged to another Baron. He has sold versions of this painting throughout the years, but finally it's out of fashion, and so I recommended that he do an abstract version. (*Gestures toward the projection.*)

BARON: Luckily, we have that show at the Met in the spring.

AGENT WOLFE: It's been canceled. The curator who was your biggest fan has been put out to pasture as the Americans say. They gave him early retirement. Blacks are running the Met, the Guggenheim, and the Whitney. The CEO of The Met described your *Mother of*

the Dead as devoid of human figures. He's a twenty-eight-year-old gay Black kid from Brooklyn who arrives at work on a skateboard. They've moved the primitive art from the basement to the first floor.

BARON: But you told me that abstract art was the trend in New York galleries, which is why I stopped doing realism. (BARON *points to the projection [his version of abstraction] and then to the realistic style painting above the mantlepiece.*)

Projection out: Bridget, Mother of the Dead.

AGENT WOLFE: It's hard to keep up with the American art scene. Nothing is permanent about this country. It's like the American singer Frank Sinatra says: "You're riding high in April, shot down in May."

BARON: Frank who?

AGENT WOLFE: He's the Italian who sent Irish tenors into retirement.

BARON: I see. (*Pauses. Thinks.*) But if they insist upon art with human figures, what about classical art? Rome, Greece, the Renaissance all include human figures. What will become of the great art of humankind?

AGENT WOLFE: You can't give that stuff away. It's all on eBay going at bargain-basement prices. It's happening all over. You can blame the Conceptual artists for this. Somebody just paid one hundred-and-two thousand dollars for a banana taped to the wall of a gallery.

BARON: That's ridiculous. The banana will rot.

AGENT WOLFE: That's part of the Conceptual art strategy. Art that demolishes. That self-destructs.

BARON: (*Contemptuously.*) What is this Conceptual art?

AGENT WOLFE: Marcel Duchamp started all of this. His earliest version was *Bicycle Wheel* in 1913, which was a bicycle mounted on a stool, and then in 1914 *In Advance of a Broken Arm*, which was a snow shovel, and *Bottle Rack,* which was just that. He coined the term "readymade" for this art form in 1915 and caused a sensation when he presented *Fountain*, a standard urinal, at the 1917 Society of Independent Artists exhibition.

BARON: What?

AGENT WOLFE: He was the founding gangster of one of the longest-running con games in art history. Conceptual art. He wooed naive bourgeois businessmen to pay his liquor bills and put him up in fancy apartments. These patrons were the first of those whom you might call the Duchumps. The urinal that made Duchamp famous wasn't even his. It was introduced to him by German-born poet and artist Baroness Elsa von Freytag-Loringhoven. He lied and said it was his. He became famous, while the baroness is dismissed as weird and strange by male critics and biographers, yet she's the one who signed the urinal "R. Mutt."

BARON: So this Conceptual art is about signing your name to an object that someone else created?

AGENT WOLFE: Yes. Duchamp wanted to sign his name to the Woolworth Building.

BARON: You mean I've been spending the last five hundred years busting my ass going through the rigorous process of creating a masterpiece. Making sketches. Buying paint, canvas, cleaning brushes, when all I had to do was sign my name to a work created by somebody else? Like a scavenger?

AGENT WOLFE: That's the trend. The new patrons don't give a shit about greatness. They are not as refined as our usual collectors. They're insisting that the museums make a profit and not just offer excuses for tax write-offs. Pharmaceutical companies, tear gas manufacturers, owners of private prisons are now footing the bills of museums. Such is the decline in taste in this country that a Chinese immigrant was caught creating forgeries of the Masters.

BARON: Was he arrested?

AGENT WOLFE: No. His forgeries are selling for more money than the originals. Even the art dealers and critics are corrupt. They demand that painters they represent, or write glowing reviews about, hand them a kickback of a painting or two. You have painters paying galleries to have their paintings exhibited.

BARON: We should have remained in Bavaria.

AGENT WOLFE: Baron, you wanted new blood. Not that stale old-world type. Sluggish. Sticky. Type AB. Ancient. Artery clogging. As nutritious as a doughnut. Besides, when someone gave you a show, nobody would show up because of your reputation. I love this town. Such is the pollution in this city that seldom does one see a full moon. Otherwise, I'd be galloping through Central Park like some fucking idiot. (WOLFE *lets out a sample sound of his affliction.*)

BARON: Agreed. You do seem less tense. As for this American blood, it is so invigorating. After my excursions into the night, I return before dawn feeling as though I could lift one thousand pounds.

AGENT WOLFE: Your state of health is excellent, but your assets are dwindling. You're almost out of the money you got from selling your English property.

BARON: What do you advise that I do?

AGENT WOLFE: Find a Black graffiti artist who would be your collaborator. That was Andy Warhol's solution. He was made to look as though he were relevant at a time when hip-hop began to take over American culture. Jean-Michel Basquiat gave him "new blood" according to Ronny Cutrone, an assistant to Warhol. Maybe that's why he admired your dad, Count Dracula. In fact, Warhol created a Dracula image on a silkscreen. Dracula biting a girl's neck.

Projection in: Poster of William Marshall as Dracula.

BARON: (*Angrily.*) I told you to never mention my father's name. He was—how does that song go—"Papa Was a Rolling Stone." He left my mother and me scrounging around for inferior blood. The blood of peasants, while he gallivanted among the rich. Charming ladies and duchesses with his old-world style. Rumor has it that he settled in Rio and is very happy there. Lives in a fancy mausoleum side-by-side with some wealthy woman that he turned. At night they terrorize the residences of the rich, carrying off debutantes. He signed his castle over to us, maybe as a result of a guilty conscience. We wanted to turn it into a bed-and-breakfast, but it was in such a state of deterioration that it was about to be condemned.

Projection out: Poster of William Marshall as Dracula.

AGENT WOLFE: (*To audience.*) I've heard this story a thousand times. (*To* BARON.) What about the collaboration, Baron?

BARON: I would never collaborate with a graffiti artist. I'd be lowering my standards.

Light cue: Fade out the BARON's *library.*

Sound cue up: "Barrelhouse Basquiat."

ACT 1, SCENE 5

Light cue: Spot on FORENSIC EXPERT I: GRACE

GRACE: (*Reading from her clipboard or recording on her phone.*) With his cave allegory, Plato anticipates the invention of film. The shadows of individuals who pass in front of a fire are projected against a wall. Prisoners view these images as reality. Andy Warhol was one of Plato's prisoners, instead of Plato's philosophers who freed themselves from epistemological bondage, even though Warhol wrote a book entitled *The Philosophy of Andy Warhol*. For him, images were reality while his life was unreal. He viewed reality through a Polaroid. But in some ways, Andy Warhol was more like Plato than any figure of the ancient world. I imagine Plato to be an icy individual (RAKSHA *enters.*), like Warhol. Someone who didn't like to be touched. Shy. As cold as a Tennessee cave.

RAKSHA: But what about those hot sexy movies he made?

GRACE: Well his models were sexy, but Warhol said that sex on the screen was more interesting than sex between the sheets. He regarded sex as work. A person obsessed with cleanliness, perhaps a result of his upbringing, he harbored a dirty secret, which he carried to his grave. He constantly complained about Jean-Michel Basquiat's unhygienic habits. Commented on his body odor. His lack of bathing. Warhol wondered whether Paige Powell, who was in a steady relationship with Basquiat, had "recovered" from him, as though she had to be debriefed. He even asked her the size of Basquiat's penis. Asked whether he would have sex with Basquiat, Warhol said he was too dirty to have sex with.

Warhol described Basquiat's living quarters as a "pigsty," yet at one point Warhol's Factory reeked from the smell of urine, and he and his associates created piss paintings.

RAKSHA: What!

GRACE: They say that the urine paintings were about art.

RAKSHA: Since when has piss become art?

GRACE: Some Native Americans use urine in their paintings. You were supposed to look into the opinions of Warhol's crowd about Basquiat. What did you come up with?

RAKSHA: (*Reads from clipboard.*) Some of the Factory habitants considered Basquiat a nuisance. In his *The Life And Death Of Andy Warhol*, Victor Bockris dismisses Jean-Michel Basquiat as a nuisance who smoked a lot of pot. Yet, Warhol was an Obetrol and meth addict, which accounted for his loss of weight at the time of his gallbladder operation. Was Jean-Michel Basquiat merely a nuisance? Warhol was a cult leader who often humiliated his followers. An actor named Taylor Mead was so humiliated after Warhol invited people to see him film Mead's butt when he promised the shooting would be private, Mead said that if Valerie Solanas hadn't shot Warhol, he would have. The shot killed him. But it took a long time for him to die, physically. Emile de Antonio made the same complaint about Warhol. The filming of *Drunk* was supposed to be private. Yet de Antonio noticed that Warhol had invited onlookers. De Antonio threatened to sue, and the film was never released. Warhol was a fan of the snuff film. Car crashes. The electric chair. Ironically, he ended up being snuffed by Valerie Solanas. After the shooting, he was said

to appear "zombielike." Like Dracula's victims. He had to wear a corset to prevent his guts from spilling out. Was Warhol's interest in Basquiat sexual? Is that what the boxing and weightlifting were all about? The posing of Basquiat in a jockstrap. A kind of complex foreplay that would never be consummated. His obsession with Basquiat's dates? His comment that Basquiat's underwear concealed a baseball bat? And what of Warhol's intense interest in underwear? It was inevitable that Calvin Klein and the Andy Warhol Foundation in 2018 would collaborate on a line of underwear that bears Warhol's prints.

GRACE: Those are some excellent leads. Gave me some ideas for my report. This is an unusual task. But I'll do my best.

Light cue: Spotlight out on FORENSIC EXPERTS. *Stage lights up on* BARON *and* AGENT ANTONIO WOLFE *in the* BARON's *library.*

Sound cue out: "Barrelhouse Basquiat."

ACT 1, SCENE 6

AGENT WOLFE: Your standards don't pay the mortgage, Baron. You have to have a huge bankroll in order to live forever. We get us one of these Black kids. A graffiti artist. He could be Basquiat to your Warhol.

BARON: That's out of the question. An artist of my stature? A student of Rembrandt. Someone who was on a first-name basis with Reubens, Steen, and de Hooch. Collaborating with a hip-hop artist?

AGENT WOLFE: Well, Western artists go Black when they become bereft of ideas. Irving Berlin stealing "Alexander's Ragtime Band" from Scott Joplin, Picasso copying African art, Piet Mondrian's *Broadway Boogie Woogie*, Rimbaud and Henry Miller calling their books "Nigger books," Stravinsky and Gershwin writing Black music, Elvis Presley stealing from Ike Turner and James Brown, Big Mama Thornton, 'Big Boy' Crudup, ninety-one-year-old Jasper Johns using the sketch of a knee by an African teenager and passing it off as his own creation. Blackness provided these artists with new blood. It'll pass. It's like a cyclical reboot. But for now, you have to pay the bills for the lavish parties. It all adds up.

BARON: Hmmm. Something to think about.

AGENT WOLFE: What about the girl?

BARON: She's having trouble sleeping during the day in such, shall we

say, cramped quarters. I told her that she will adjust to the new normal. I got her here by promising her a collaboration. She'd be my partner in a performance piece. Talk about innocence. Now this detective is showing up, asking questions. A Black woman with a Dutch name. Odd…

AGENT WOLFE: The Dutch were the first slaveholders in New York.

BARON: Didn't know that.

AGENT WOLFE: How does the girl taste?

BARON: Incredible. Her blood has that extra fizz. (*Gestures, fingers to mouth kisses.*) She is the archetypical American girl next door. The cheerleader you see at football games. But I think that the Chinese cleaning woman has been snooping around in the basement where we—ahh—rest during the day. I've requested a new cleaning woman. I think that the present one is a police spy. She speaks Chinese when I'm present, but I caught her making a phone call. She was sitting in a comfortable chair. She had her feet propped up on a stool, she was smoking a cigarette, her favorite soap opera was on the TV. She was speaking perfect English. When she saw me, she switched back to Chinese. She's probably the one who tipped off the detective.

AGENT WOLFE: We should dispose of her?

BARON: No. I'll fire her.

AGENT WOLFE: But suppose she tells—

BARON: Who would take a Chinese cleaning woman's word over

mine, a baron. Yet, you want me to collaborate with some street scum. Listen, if she makes trouble, we'll do with her what we did with the rest.

AGENT WOLFE: What's that?

BARON: If she goes around spreading tales about what goes on in this house, we put her in Bellevue.

AGENT WOLFE: But you have more pressing needs than that. You hook up with a hip-hop painter as Warhol did. You can pay for the maintenance of this townhouse. Pay me. I've done some research in an attempt to find a candidate. There's a boy named Young Blood. He is inspired by SAMO.

BARON: SAMO?

AGENT WOLFE: (*Spells out.*) S-A-M-O. Same Old Shit. It's the group that Basquiat belonged to. They went about on the Lower East Side drawing graffiti on buildings and painting on postcards.

BARON: So what if I did collaborate with this Young Blood? What would my job be?

AGENT WOLFE: You'd insert product names into the paintings of Young Blood. Basquiat remembers his collaboration with Warhol this way: "[Andy Warhol] would start most of the paintings. He would put something very concrete or recognizable, like a newspaper headline or a product logo, and then I would sort of deface it, and then I would try to get him to work some more on it, and then I would work more on it. I would try to get him to do at least two things, you know? He likes to do just one hit

and then have me do all the work after that." Basquiat said that Warhol was lazy. That he did all the work. The graffiti artist will do all the work which will give you time to go about your nocturnal errands. Insert your icons into the paintings and then you're on your way.

BARON: Icons! (*Recoils as if dodging a cross.*) Are you crazy? You know I have an aversion to icons?

Projections in: Series C: Logos.

AGENT WOLFE: Secular icons. Brand names. The stuff you find in grocery stores. You insert one of their brand names into paintings done by him. That was Warhol's job. His philosophy was that if an object is in a grocery store, it's a shopping item. If it is in a gallery, it's art. He and the members of his factory made facsimiles of Brillo Boxes, Heinz Tomato Ketchup, Mott's Apple Juice, Del Monte Peach Halves, Campbell's Tomato Soup, and Kellogg's Corn Flakes. It didn't begin with his using Basquiat. Warhol told Emile de Antonio that he'd quit painting and that his painting was done by Brigid Berlin.

BARON: Is that all? I just have to insert brand names in his paintings?

Projections out: Series C: Logos.

AGENT WOLFE: As simple as that. Feed him caviar and cocaine. He can use our GrubHub account to order food from White Castle. That way he'll work twenty-four hours a day and be very productive. Create a studio in the basement where he can work. That's how his agent Annina Nosei treated Basquiat.

BARON: Let's do it.

BARON *and* AGENT ANTONIO WOLFE *execute an elaborate handshake.*

Light cue: Lights fade out on BARON *and* AGENT WOLFE *and spotlight fades up on* FORENSIC AGENTS.

GRACE: Raksha, do you have something about Bram Stoker, the author of *Dracula*, and Warhol?

Sound cue: "Barrelhouse Basquiat."

RAKSHA: (*Reads from clipboard.*) Like Bram Stoker, Warhol was a sickly child whose only contact for one summer was with his mom and a Charlie McCarthy doll. Maybe that's why he anticipated a time when humans would marry non-human entities.

Projections in: Series D: Humans with non-human marriage partners.

Like Eija-Riitta Eklöf-Berliner-Mauer. She married the Berlin Wall in 1979, and Erika Eiffel, the Eiffel Tower in 2007. In 2015, Floridian Linda Ducharme announced that she was in love with Bruce, who is a Ferris wheel, and when Bruce was in bad shape, she, like a good wife, donated $100,000 for his restoration. In 2016, Zheng Jiajia created a robot, named her Yingying, and married her. In 2012, Babylonia Aivaz vowed to love and cherish a Seattle warehouse in front of a crowd of fifty onlookers. In the late 1950s, Warhol said he began an affair with his television set but eventually married his tape recorder, which he called "my wife."

GRACE: I'll bet that Plato was in love with the Parthenon.

Projections out: Series D: Humans with non-human marriage partners.

RAKSHA: There you go again, showing off your classical learning. Let's get some coffee.

GRACE: Good idea. (GRACE *and* RAKSHA *exit.*)

Sound cue out: "Barrelhouse Basquiat."

Lights fade, and when GRACE *is in place again, fade up.*

ACT 1, SCENE 7

GRACE: (*Reads from clipboard.*) The relationship between Andy Warhol and Basquiat was more like that between a primatologist and a creature than one between two painters.

Sound cue in: "Tolls for Basquiat."

He spent more time observing Basquiat's comings and goings, his dining habits, than contributing to their paintings. He was a voyeur for whom the lives of others were more interesting than his own. Warhol took copious notes about those individuals who fascinated him. An heiress named Taxi, a.k.a. Edie Sedgwick, for example. No wonder Basquiat at one point said that he was treated like a monkey, or as one artist said, his contribution was "intuitive primitivism." Basquiat was like Ota Benga to Warhol and his circle.

Projection in: Ota Benga.

Ota Benga was a Twa who was placed in the Bronx Zoo because they couldn't determine whether he was human. Of his reviewers, Basquiat said, "They're just racists. They have this image of me—wild man, monkey man, whatever the fuck they think." But aren't the signs of a primitive that of aping things?

Projection out: Ota Benga.

Warhol made his reputation by duplicating the creations of others. Even after his death, there are those suing him for

plagiarism. When he was asked to respond to critics who said that he wasn't original, he agreed with them. When asked why he copied others he said, "it was easier."

Sound cue out: "Tolls for Basquiat."

People were amazed that the two, so different, would become collaborators. Basquiat included strong Black militant references in his work. Eighty percent of the faces in his paintings are angry. It's as if he painted with a shotgun instead of a paint brush.

Projection in: Shah of Iran on the Peacock Throne.

Warhol interviewed Nancy Reagan and worked for the Shah's brutal fascistic Peacock Throne. Basquiat fought injustice.

Projection out: Shah of Iran on the Peacock Throne.

Sound cue in: "Tolls for Basquiat."

Early on in Basquiat's career, a young graffiti artist named Michael Stewart was caught drawing the words "Pir Nema Pir Nema" on the subway. He went into a coma and later died after a beating by the NYPD. Basquiat made a furious painting called *Defacement* showing cartoon drawn cops beating Stewart. Was Basquiat inspired by Miles Davis? Charlie Parker? Ishmael Reed disagrees: "No. Too gentle. Too cool."

Sound cue out: "Barrelhouse Basquiat."

Projection in: B SERIES, names of musicians.

Miles's playing was described by a critic as sounding like a man walking on eggshells. Basquiat crushed eggshells in his hands. His paintings were not a songbird but a Black vulture. A Black vulture attacking a cow. Music and Basquiat? Maria Callas? No. Howlin' Wolf. Junior Wells. Big Maybelle. These paintings sound more like Earl Bostic, Illinois Jacquet, Big Jay McNeely, Arthur Prysock. Dizzy Gillespie. Art Blakey. Ben Webster. Louis. Brassy. Hot. Provocative. Belligerent. In your face.

Projection out: B SERIES, names of musicians.

By contrast, Warhol partied with members of the Reagan administration and Nancy's "beautiful white people." The relationship was also like that between an employee and employer in one of those company towns before child labor laws. (RAKSHA *enters, excitedly.*) In these towns the workers were not only exploited by the bosses but had to pay the bosses rent.

Projection in: Company town.

RAKSHA: Funny that you would say that Grace. Look what I found. (*Reads from clipboard.*) Basquiat rented an apartment in a building owned by Warhol. Basquiat paid Warhol $4,000 per month while maintaining residences at five-star hotels like the Ritz-Carlton. So when Basquiat wondered out loud whether he was a mere "flash in the pan," Warhol wondered whether—if this Basquiat statement was true—how Basquiat would pay the rent to Andy Warhol Enterprises. So he was making money off the kid going and coming. He wasn't the only one.

Projection out: Company town.

Sound cue out: "Tolls for Basquiat."

Light cues: Light out on FORENSIC EXPERTS. *Lights up on street scene area.*

ACT 1, SCENE 8

On the street in front of the Hottentot Gallery, which is scheduled to exhibit a collaboration between BARON *and* YOUNG BLOOD, *a graffiti artist. (The gallery can be represented by a painted flat that is wheeled onstage from the wings at the top of the scene and then wheeled off at the close of the scene.) A homeless Black man,* JACK BROOKS, *sits wearing a hoodie, dark glasses. Holds a tin cup.* YOUNG BLOOD *enters from the opposite direction. All he wears is a bikini and cowboy hat.* JACK BROOKS *speaks as* YOUNG BLOOD *passes him.*

JACK BROOKS: Hey, young man, can you spare a dollar? I haven't eaten breakfast, dinner, or lunch for that matter.

YOUNG BLOOD: (*Reaches inside his cowboy hat.*) Wait. Aren't you Jack Brooks? (YOUNG BLOOD *hands* JACK BROOKS *a ten dollar bill.*)

JACK BROOKS: The same.

YOUNG BLOOD: You were big back there in the '60s. What happened?

JACK BROOKS: Abstract Expressionism went out of style. That's what happened. We were hit by a tsunami of Pop art, Conceptual art, Graffiti art, Earth art, Installation art, animation, and other upstarts. People wanted paintings with human figures in them again.

YOUNG BLOOD: I never understood why you Black guys went for that abstract style of art. Art with no feeling, no guts, no humanity. The chilly aloof White aesthetic. All form and no feeling. Can

you imagine someone being moved to tears upon viewing a Jackson Pollock? You guys had your fling. Painting forms that could be found in any geometry textbook. Preferring color over content. No wonder the CIA preferred your work over political art. So did the capitalists. No risk of having someone like Lenin showing up in a picture. Thousands of provocative, political, and stirring pieces of Socialist art were destroyed so that Abstract Expressionism could thrive.

JACK BROOKS: For a while. Our world began to crumble on Halloween, October 31, 1962. We abstract painters got tricked and treated. It was the very first show of the original Pop artists—including Warhol, Lichtenstein, Segal, and Indiana. The homophobic Abstract Expressionists were done. It so outraged and offended the old-guard Abstract Expressionists (de Kooning, Rothko, Motherwell, etc.) that they all resigned from the Janis Gallery in protest. The macho types who hung out at the Cedar Bar. Drank and sometimes fought all night and then, as Fielding Dawson put it, when the bars closed at 4:00 a.m., looked for a chick to take home. Since we copied everything they did, we were put out of business too. Abstract Expressionism was the only way that the White galleries would accept us. Our only ticket to the big time. Now what were we going to do? A lot of us got our start doing political art, but then there was a backlash on political art. Museums stopped displaying us. Collectors stopped buying us. We were in a battle royal over which of us would be accepted. It was an early form of Black-on-Black crime. It was like the hip version of the auction block. In New York, to be a successful Black artist, writer, or playwright, you need a White individual or organization to sponsor you. So just as we settled in with Abstract Expressionism, these White folks changed up again on us. With no warning, they started pushing this department store

art. Andy Warhol and all of these people who'd learned their techniques working at Macy's and Gimbels. There was room for a few Black Abstract Expressionists, people who sold out, but the rest of us were forgotten. Adding to that, Minimalism started taking over as soon as we got Pop art figured out. (*Sighs.*) It's hard to keep up with these White folks.

YOUNG BLOOD: Well that won't happen to me. Baron De Whit has asked to collaborate with me. This is an honor. And answer me this. Why did you guys think that you were any different from the early slave painters? Calling yourselves the vanguard. You were like them. Doing art to please White people. Portraits that flattered White people, members of the slaveholding aristocracy. Like you, Black painters of that period were doing escapist landscapes while the country was teetering toward a Civil War. They were painting apples and oranges while Black poets and orators were risking their lives by agitating against slavery. At least the Black poets of that time addressed the issues of the day, while the Black painters were eager to drop out. So there's no difference between you and them. Escaping the turmoil of the day. Running off to Paris and Rome like you're fleeing the real world for a world of form. You can understand why the Black painters of that period would shy away from political art, since any sign of dissent could get them killed, but what was your excuse? You figured that Black people couldn't afford to buy paintings and so you sold your souls to the highest bidder. Sellouts. I went to that Black show at the Brooklyn Museum. The only work that made sense was Norman Rockwell's illustration of the Federal Marshals escorting that little Black girl into the segregated school.

JACK BROOKS: Do you think that working with the Baron will turn you into a Malcolm X with a paintbrush?

YOUNG BLOOD: It's a start. Working with Warhol put Basquiat in a position to paint work that was political, like Basquiat's *Defacement*.

JACK BROOKS: They're going to do the same thing to you that Warhol and that debauched bunch did to Jean-Michel Basquiat. Killed him with dinner parties and drugs. After they absorbed his vitality, they abandoned him. What they wanted was his "new blood," as Sotheby's put it.

YOUNG BLOOD: Oh yeah, you wish that you had all that. Just like you elderly Black people. Afraid to seize an opportunity. I can't waste my time talking to you. You're a fading anachronism. We're the woke generation.

JACK BROOKS: You don't get it, do you? They see you as a savage. At least we Black abstract painters had our dignity, no matter how fierce we were as competitors. And how can they call you a primitive outsider? I read in *ARTNews* that your father is an optometrist, and your mother is a schoolteacher. You went to art school. You're like those middle-class Black kids who spend a couple of weeks in the hood and then record a hoodie hip-hop song that is a hit. They fake their biographies. Telling everybody that they grew up in Bed-Stuy when their address was actually Scarsdale. You look silly in that costume by the way. Aren't those the colors of Marcus Garvey's Universal Negro Improvement Association?

YOUNG BLOOD: Marcus who? (JACK BROOKS *looks surprised, then laughs.*)

YOUNG BLOOD: Well, the Baron's asking me to collaborate with him is the biggest break that's come in my career. As for the outfit, Whit is going to introduce me as his collaborator at a press conference. He told me to dress this way. For publicity.

JACK BROOKS: You sure you want to collaborate with the Baron? He lives in that townhouse uptown. Scene of weird happenings. Strange parties. Some are known to enter and then go missing. And whenever Baron De Witt enters a scene, people say that they hear the sounds of wolves. And why do you suppose that he scheduled the press conference during the night. Don't you find it odd that nobody sees him during the day?

YOUNG BLOOD: You're just jealous because he didn't choose you. An old-school loser. You had your chance. You old farts make me sick. Ain't nobody told you to abandon the people and do that sterile European thing.

JACK BROOKS: Okay now. Don't say I didn't warn you. You're nothing but a mascot to the Baron. (YOUNG BLOOD *flips off* JACK BROOKS *as he exits.*)

JACK BROOKS: Another lost soul. I was naive too. Put my faith in solidarity with New York painters. So when the Whitney Museum announced that they were going to do a Black show, I felt that we had arrived. Oliver Grey called and said that the Black painters were going to boycott the show because it was curated by a White person who didn't know our culture. A lot of Black painters besides me heeded Oliver's demand and withdrew their paintings. Some didn't and they crossed our picket line. Guess who was among those who crossed the picket line? Oliver Grey. I'll never forget the look on his face when he saw me.

He just about ran into the building. He'd called for us to join a boycott that he violated. He wanted to be at the top of the heap. As a result of his treachery, Oliver Grey's reputation soared with the rest of us out of the way. Boy, was I mad. I went to his loft. We got into a fierce argument. After that he disappeared, never to be heard from again, at the height of his success. He disappeared because I killed him.

Light cues: Fade out on street scene with JACK BROOKS *and fade up on* FORENSIC EXPERTS.

ACT 1, SCENE 9

GRACE: You're saying that an art dealer encouraged Basquiat to use drugs so that he would produce more work. That's a pretty serious charge, Raksha.

Sound cue up. "Barrelhouse Basquiat."

RAKSHA: No one is saying that Annina Nosei supplied him with drugs. She, like the others, just looked the other way as long as they were gaining profits from his labor, energized by his cocaine habit. Listen to this: (*Reads from clipboard.*) She placed him in her basement. Given Basquiat's set up there, some called it "a dungeon." He was now in a position to buy a lot of drugs. The drugs led to his producing more. Slaves and workers were treated in a similar manner, the only difference being that they were forced to take cocaine by their employers and masters in order to increase production. Cocaine helped Basquiat meet the demands of Nosei, who rushed his paintings into the market even though some were unfinished. Sometimes at a rate of six paintings per week. That's how Annina Nosei treated Basquiat. Of course, he had imbibed drugs before, but now with the money made from paintings she sold, he increased his intake of drugs. Reports from the "dungeon" where she installed Basquiat in 1981 find him in a pitiable state. If we're looking for foul play, what could be fouler than that? Basquiat said of the Nosei arrangement that because he was young, he didn't realize that he was a victim.

GRACE: He could have said no.

RAKSHA: He was just a kid, Grace. She gave him enough money to rent limousines. Buy Armani clothes. He got paint all over them. He was propelled from living on the streets to fame, money, drugs, women. It was too much. He was only twenty-two.

GRACE: He got paint all over the Armani suits?

RAKSHA: He was known to lose expensive clothes. Leave them in restaurants. May I continue? (*Reads from clipboard.*) Collector Doug Cramer remembers, "He was painting away. He looked like a slave, or very close to it." Rich White people were invited to the basement to gawk at him as though he were the Elephant Man. Sculptor Arden Scott describes a visit: "There was coke falling all over the place. It was so awful it made my skin crawl. It was really a bad model to have an artist in the basement making work." Said Diego Cortez, the curator of the show, *New York/New Wave*, which was the first art exhibit to include Basquiat's paintings, "It was like, 'I've got this Black laborer in the basement. Look at this kind of zombie freak circus person making art.'" Basquiat said that he was treated like a "mascot." Though the Whites who write Basquiat books view Andy Warhol as a "father figure" who showered Basquiat with kindness, it was Basquiat who got him to paint again.

Sound cue out: "Barrelhouse Basquiat."

Unlike Warhol's disciples, Emile de Antonio saw through the spin put on the relationship created by Warhol worshippers. "To most people Jean-Michel dominated Andy—Andy had been victimized. But I saw it quite the other way. I came to the conclusion that Andy was the prime mover of a fairly evil thing in relation to Jean-Michel." Photographer Christopher Makos,

who introduced Basquiat's work to Warhol, saw the relationship as yet another example of "vampire lesbianism."

GRACE: I'm impressed—you've put a lot of work into this. Originally you said that this assignment was a waste of time.

RAKSHA: It caught my interest. I stayed up until 4:00 a.m. putting two and two together. Check this out. (*Reads from clipboard.*) Basquiat was even more like Cinderella than Warhol. He was abandoned by his father and a schizophrenic mother. Cinderella's father betrayed Cinderella by marrying a nagging, prying bitch who was jealous of her. And then like her mother before, he died on her. The stepsisters were envious of Cinderella, like stepsister Warhol was envious of Basquiat. There were no happy endings for either Basquiat or Cinderella. Cinderella married a prince, but he was overthrown by a coup and Cinderella was placed in a dungeon. And like Miles Davis, another Cinderella, Basquiat's prince never came.

Light cues: Out on FORENSIC EXPERTS *and up on street scene area outside Hottentot Gallery.*

ACT 1, SCENE 10

BARON DE WHIT *and* AGENT WOLFE *are leaving the Hottentot Gallery, where the opening for the exhibit of the collaboration between the* BARON *and* YOUNG BLOOD *has taken place. They meet* DETECTIVE MARY VAN HELSING, *who has been waiting for them on the street outside the gallery.*

MARY VAN HELSING: Congratulations on the show. I thought that Young Blood, your collaborator, would be here. What happened?

AGENT WOLFE: (*Nervously.*) He came down with the flu.

MARY VAN HELSING: His work is not as impressive as Basquiat's. But it'll do. (*To* BARON.) What was your contribution to the show?

BARON: (*Nervously.*) My contribution? The logo for Tabasco sauce. Did you enjoy it? That was my contribution.

AGENT WOLFE: Young Blood is lucky. He's hitchhiking on the Baron's name.

MARY VAN HELSING: Looks to me like the Baron is the one who is benefitting. I checked your sales. Pretty low. Looks like people are tired of drawings of this Mother of The Dead, your obsession—

AGENT WOLFE: Yes, we've heard that criticism before.

Projection in: Archie Moore's face on a leopard body, with name spelled as "Archy More."

MARY VAN HELSING: And why are these art dealers making such a fuss about Young Blood's picture of Archie Moore, the former light-heavyweight champion of the world? That don't look like no Archie Moore to me. It looks like something a child could have drawn. And what's with that crown on his head?

Projection out: Archie Moore's face on a leopard body.

He went to some fancy art school, so he knows how to spell.

AGENT WOLFE: We instructed him to misspell. What would graffiti art be without bad spelling? Bad spelling is trending. Part of Young Blood's genius is his being untamed, raw, and powerful. The crown is a tribute to the late Jean-Michel Basquiat. His idol.

MARY VAN HELSING: Well, I hope he gets better. Still, it's strange that he would miss the opening of the show.

AGENT WOLFE: We have to go to the reception.

BARON: Is that all, Detective?

MARY VAN HELSING: You can go. But I'll be checking in with you from time to time.

BARON: Well, I'm glad to cooperate, Detective, but in the future, I want you to call ahead instead of just showing up.

MARY VAN HELSING: This is not Europe, Baron. We don't recognize no titles over here. We show up any time we wish when a kidnapping is involved.

BARON: I thought that when I sailed into New York Harbor and saw the Statue of Liberty, I thought this country would be different.

MARY VAN HELSING: But weren't you the one who said that the Statue of Liberty had to be created by a European sculptor because America never produced a first-rate sculptor?

AGENT WOLFE: We're late, we have to get going. (*The* BARON *and* AGENT WOLFE *exit.*)

MARY VAN HELSING: (*Crosses to DSR monologue area.*) I'll bet they're doing to this new child what Andy Warhol and his band of vampires did to Jean-Michel Basquiat. He was exploited by those art dealers and collectors. They got new blood all right. He thought that they were his friends.

Projection in: Downtown Art Group photo.

That's where this naive child went wrong. They were no friends of his. They were out to make money. The child died at twenty-seven and they're still using him. Bergdorf Goodman selling his sketches for $2,000. Tiffany & Company using his painting in a full-page ad in the *New York Times*, November 6, 2021. A clear case of commercial slumming. Louis Vuitton publishing his books.

Projection out: Downtown Art Group photo.

The Black woman who preceded me, one of those historic firsts, told me that she tried to tell the precinct captain back there in the 1980s that they were giving this child heroin, but he wouldn't hear of it. He told her that she was an affirmative action hire, and she should stay out of trouble and not get involved in something

that was above her pay grade. He said that Warhol was not only a powerful celebrity but owned buildings. One of the Black cops took her aside and told her that the department had a hands-off policy when it came to the rich, White, and powerful, but when it came to hippies and Blacks, the walls of the 9th Precinct were caked with their blood. She failed to save Jean-Michel, but maybe I can save this new fool. This precinct captain can't be as crass as the one she worked under. Times have changed. He can't control me. He said that I was spending too much time trying to solve the case of this missing Black girl, Jennifer Blue, and that the Baron was complaining about my pestering him. The captain started to walk away. I grabbed him by the collar. I told him, "Don't you be walking away from me when I'm talking to you." Shocked, cops in the station gathered around. I said, "You nearly call in the National Guard when a White girl is missing. The news media be broadcasting missing White girls around the clock. Look at that no-singing no-dancing Britney Spears, trying to free herself from her father. She ain't even kidnapped. But that's all you hear about. Britney Spears, Britney Spears. She gets more coverage than the Lord's mother. If she ever got kidnapped the government might declare martial law." Well, he said all nervous, "I'll give you another week." I looked the sucker right in the eye and I told him, "I ain't leaving this case until I find out what happened to Jennifer Blue."

Lights cross-fade: Out on street scene, up on FORENSIC EXPERTS *area as* DETECTIVE MARY VAN HELSING *walks to their desks and picks up a copy of the* New York Times, *tucks it under her arm, when she encounters* RAKSHA *who is walking to her desk.*

MARY VAN HELSING: (*To* RAKSHA.) Are you making any progress on the Basquiat matter?

RAKSHA: Yes, Detective Van Helsing. We'll have something soon. (DETECTIVE MARY VAN HELSING *waves and continues to exit.*)

RAKSHA: (*Reading from clipboard.*) One critic called Basquiat "Warhol's mascot." When the mascot behaved, he was rewarded. When he misbehaved, he was punished. During a trip to Milan, Warhol physically assaulted the boy, which must have reminded him of the blows he took from his father. Warhol boasted about it.

Sound cue up: "Barrelhouse Basquiat."

Warhol was upset because Basquiat received more attention in Italy than he did. Warhol was cruel to his children. Was Basquiat one of those young people who was harmed by his association with Warhol? "Basquiat fit right into the well-established Warhol youth-culture mythos," according to Dotson Rader, who had written about his "warped Pied Piper role" in a 1974 *Esquire* article entitled "Andy's Children: They Die Young." Wrote Rader: "He is like an overindulgent scoutmaster who slips the kids grass and ignores the sounds coming from the pup tents at night. Warhol is a father figure to the kids around him, but he is an insufficient one. He listens and watches but can never come up with more than an 'Oh, really?' to their need." Paige Powell was so concerned about Basquiat's drug addiction, she asked Warhol to intervene. Warhol's response? He said, "Maybe he wants to be the first to go out early."

In a review of Warhol's *The Philosophy of Andy Warhol*, Barbara Goldsmith wrote: "The important message is how Warhol managed to make himself into a machine-like presence devoid of empathy." He had a falling out with Edie Sedgwick when she and Bobby Dylan had a relationship. Maybe the reason he

expressed no empathy toward Edie and Jean-Michel was because he saw himself as a fellow teenager. The same reviewer said that Warhol's musings came off as the musings of a teenager. Basquiat even asked Warhol's permission to marry his girlfriend, Paige Powell. But "the father" was absent when they needed him. After he'd gotten everything from them—Edie's beauty, Basquiat's potency—they were cast aside. When told that Edie Sedgwick might commit suicide, Warhol quipped, "I wonder if Edie will commit suicide. I hope she lets me know so I can film it." Losing the affection of the father, like Cinderella, whose father, a baron, died when she was a kid, Sedgwick and Basquiat became what sociologist Phyllis Chesler would call "father wounded." Wounded by Warhol. Both died at almost the same age, between 27 and 28. From overdoses. Warhol could not aid these young people. Warhol made a similar remark when he heard of dancer and choreographer Freddie Herko's suicide. *The Palace of the Dragon Prince* and *Villanelle*, by Herko, premiered at Judson Memorial Church, featured a rising star named Carla Blank. Warhol said that "he wished he had been able to film Herko's death too." Herko was 26. Overhearing this remark, Warhol's screenwriter Ronald Tavel said, "Sometimes I admit that his coldness was shocking. Some of his responses that he made to the deaths at the Factory I could not believe." Tavel tried to sue for payment for his screenwriting. Warhol's hiring of a fancy lawyer discouraged him. His obsession with suicide became so intense that he made a black silk screen painting based on a photograph given to him by a policeman that showed the scene where a young woman had leaped to her death. She was lying face down. Crushed on the brick pavement, in the courtyard, having fallen from the eighth-floor window. Warhol made a joke about the suicide of hundreds of Jim Jones followers—said that if they had drunk poisoned Campbell Soup instead of Kool-Aid,

then he, Warhol, would have made the news. But wasn't Warhol a wig-wearing minor Jim Jones? Is there such a thing as foul play by neglect? I'll email these notes to Grace.

Sound out: "Barrelhouse Basquiat."

Onstage lights out and house lights up for Intermission.

ACT 2, SCENE 1

Light cue: House lights out and fade up on GRACE *or an offstage voice.*

GRACE: (*To* RAKSHA.) Jack Brooks, who turned himself in for the death of Oliver Grey, the famed Black Abstract Expressionist, was convicted of manslaughter today. The judge sentenced him to two years in prison. Before he was led away to begin serving time, Brooks moved some of those present in the courtroom to tears as he pled his case. After many years of bad luck, Jack Brooks received some good news when the judge who had collected some of his paintings presided over his trial. The judge sentenced him to serve time in a minimum-security prison.

Light cues: Fade out in FORENSIC EXPERT 1: GRACE *and fade up on monologue area for* JACK BROOKS *in court.*

JACK BROOKS: Judge, thank you for granting me the opportunity to make a statement. Your honor, members of the jury, audience members. First of all, I want to extend my apologies to members of the Grey family for my being responsible for Oliver Grey's death. It was an accident. As I said when I was testifying, I was steaming about Grey's deception when I went to his SoHo loft. He pretended that he wasn't home, but when one resident exited from the building, which you had to press a buzzer to enter, I entered. His door was open. He was startled to see me. I grabbed him and we began to wrestle. He fought back. In fact, he was getting the best of me. I'd forgotten that he'd been a boxer while a member of the Navy. But then he stumbled and hit his head

against the radiator. I tried to revive him, but it was useless. I panicked. Yes, I could have called the police, but since there are hundreds of Black and Brown people in New York jails who are innocent or who can't make bail, I didn't want to end up in some place like Rikers Island, one of America's Devil's Islands, where I could have been murdered.

Let me tell you a little about my background. I came from a region of the country where farmers were moved by the true populists' attitudes. Where the needs of the individual were subsumed under the needs of the group. I was not prepared for the fierce competition for the few positions open to Black artists in the city of New York. That accounts for the cut-and-shoot attitudes among Black artists. You see it in the murders that young rappers inflict upon each other. This extends to the fights over which jazz musicians will be signed for gigs and record contracts. That's what brought me into conflict with Oliver. I got tired of hiding and living among the forgotten. It's when I encountered the young artist Young Blood that I decided to turn myself in. Artists like me provide a bridge to the past. Someone who can tell the younger artists about the issues and questions that confronted my generation, so that they don't start out at zero, a blank slate. Like Jimmy Santiago Baca and Malcolm X, I will use my prison time wisely. Improving my artistic skills and imparting wisdom and instruction to the untapped talent available in the prison where they send me.

Sound cue: Applause. Followed by the judge's gavel and the judge saying, "Order in the court."

Light cues: Fade out on JACK BROOKS *and fade up on* FORENSIC EXPERTS *at their desks.*

ACT 2, SCENE 2

FORENSIC EXPERTS *are working at their desks.*

GRACE: (*Relaying courtroom scene to* RAKSHA.) The audience was so moved by Brooks's statement—

Sound cue fade up: "Tolls for Basquiat."

—that one of the hardened guards embraced him. So, we know who killed Oliver Grey but who killed Jean-Michel Basquiat? The decadent Warhol circle? The insults from the museums like New York's MoMA, which said that exhibiting his work would be a waste of space? The commissions that had him turning out work twenty-four hours per day from a patron's dungeon? The insults from Whites in the United States and abroad both from art-world insiders and from those who crossed his path in everyday life? Phoebe Hoban in her *Basquiat: A Quick Killing in Art* wrote, "He was treated weirdly, strangely, like he was an oddity. People were entertained by him, fascinated for the moment, but would sooner or later throw him away. Or he was feared, you know? Just genuinely feared."

No matter where he went in the world, Basquiat was pulled over. A White photographer recalls, "In Paris, with guns drawn, the police asked if a woman who had fallen asleep in the back seat of his car was dead." Was he killed by the critics? Basquiat stopped talking to Warhol after reading their texts.

RAKSHA: Can you read some?

GRACE: Particularly nasty, vicious, and cruel was Hilton Kramer, who wrote, "He was essentially a talentless hustler, street-smart but otherwise invincibly ignorant, who used his youth, his looks, his skin color and his abundant sex appeal to win an overnight fame that proved to be his undoing. Yet for a few vertiginous years before he died of a drug overdose in 1988, big-time art dealers were vying for his work, critics were singing his praises and collectors, almost as ignorant about art as Basquiat himself, were outbidding each other to acquire his daubs and scribbles." Basquiat accuses the art dealers of pimping him and art critics of being maggots, maggots on his corpse. Though one of the art dealers, Mary Boone, is depicted in the stories about Basquiat peddled by White writers and Julian Schnabel as someone who was burdened by her relationship with Basquiat. One critic had it right. Calling her a kind of female Sammy Glick. Mary Boone went to prison for tax fraud. She received thirty months. She spent $800,000 on an apartment renovation, and $19,000 on a shopping spree at Hermès and Louis Vuitton. Did she pilfer money from Basquiat?

RAKSHA: (*Reading from a clipboard.*) The emergence of critics from colored backgrounds has rendered such White ethnocentric pronouncements obsolete. Who was the primitive? Basquiat, who drew inspiration from multiple traditions, or his White critics, whose devotion to White supremacy and whose narrow Eurocentric education rendered them incapable of detecting how these traditions influenced his work? The reaction to these new critics has generated the kind of typical mass hysteria that bursts to the surface in the U.S. from time to time. Instead of requesting a refund from Princeton, Harvard, and Yale, which provided them with a fake Eurocentric point of view, as useful as a fax machine when assessing the complex racial history of the

United States, they strike out. Accusing their critics of identity politics because they resist identifying with them.

GRACE: Nothing new. The Emperor Hadrian gave the Jews a hard time because they refused to Romanize.

RAKSHA: The Emperor Hadrian. There you go again. What does the Emperor Hadrian have to do with it. Isn't he the one who built some silly wall in England?

GRACE: Basquiat frequently cites the classics in his work. Besides, in his paintings Basquiat shows that he is very familiar with the Western Classical tradition. In his painting, *Jawbone of an Ass* (1982), Aristophanes, Socrates, and Sophocles are cited.

RAKSHA: While you've been rummaging through the classics, trying to find an analogy between some Emperor and Basquiat, I interviewed a Native American critic, Charleen Touchette, who has a different point-of-view, which Kramer and other White critics, viewing themselves as members of the master race, failed to discern. She is an artist who lives in Santa Fe, New Mexico.

Projection in: Pictograph sources of Basquiat's Native American images.

RAKSHA: (*Reading from clipboard.*) Touchette said: "Not surprising that Eurocentric critics ignored the Native influence on Jean-Michel because they had no way of knowing that he had seen the art I showed him, and even if they did, they would have probably not acknowledged it since they didn't value anything American Indian. By the way, these Jean-Michel Basquiat paintings also show the influence of contemporary Indian Art

on his compositional style, use of pictographic symbols, and Indigenous political ideas, and his use of imagery associated with Indians like arrows, tipis, horned figures, or masks, and barbed wire signifying reservation confinement. Jean-Michel and I also spoke about how he connected to his family's Indian ancestry, too."

Projection out: Pictograph sources of Basquiat's Native American images.

Invincibly ignorant? Basquiat knew Western art and did parodies of work by "The Masters." Not as a copy-cat but as a jazz musician would take the chords of a Tin Pan Alley classic and reharmonize them. But he wandered into territory that was deemed off-limits to Kramer and his White supremacist posse. Basquiat knew African art as well, having traveled to Africa. Basquiat was eclectic. Multicultural. Kramer was stuck in his taste. Unmovable. The narrowest of Eurocentrics. So why should we accept the terms they used to define Basquiat's art? White critics, knowing little about the traditions of others, attempt to define them using their terms: Neo-Expressionism, Primitive, and Afro-Futurism. Why not Neo-Indigenous? They said that he must have been influenced by Jean Dubuffet. Basquiat told them he had not been influenced by Dubuffet. They called Basquiat a liar.

Sound cue fade out: "Tolls for Basquiat."

GRACE: Raksha, I found Robert Hughes's comments to be equally cruel. (*Reading from clipboard.*) Like other advocates of "high culture," Hughes said that whenever Blacks or women make strides it's due to "political correctness." We hear that all

the time around here. He wrote: "monochrome late American art industry felt a need to refresh itself with a touch of the 'primitive.' The reputation may survive, or it may not. If it does, it will only show once more, as if further proof were needed, that a perch in the pantheon of the 1980s does not necessarily depend on merit. His stardom was waning badly when he died, because the fashion that had raised him up was already tired of him. Syringes flung cruelly by the Zeitgeist. The only thing that brought Basquiat back into the spotlight was his death."

And listen to this. (*Reads from clipboard.*) Those who provided the research for the TV news show *60 Minutes* planted Hughes's idea in Morley Safer's script:

Sound cue up: "Barrelhouse Basquiat."

"Shown with a group of Black schoolchildren at the Whitney Museum of American Art's retrospective of Jean-Michel Basquiat's work, Mr. Safer asks, 'Do you think you could do as well?' 'Yeah,' responds one of the children. 'I could do better than that.' Of Basquiat as an artist, Mr. Safer explained to viewers that 'in 1988 when his popularity was declining, his career was saved.' 'He died of a drug overdose, and now that there would be no more Basquiats, the market fell in love with him all over again.'"

Yes, he died of an overdose, but who led him there?

RAKSHA: Are you saying that someone killed him with an overdose.

GRACE: No. They set the conditions, the atmosphere which led to his using drugs, excessively.

RAKSHA: (*Reading from clipboard.*) Another example of so-called critical analysis came from Vivien Raynor, who published her review in the *New York Times* of the 1985 Tony Shafrazi Gallery exhibit featuring the collaboration of Basquiat and Warhol. The two artists had a falling out after the show drew criticism. Was Basquiat exploited? When discussing this show of Warhol and Basquiat's collaborative works, Raynor stated in an almost racist tone: "Last year, I wrote of Jean-Michel Basquiat that he had a chance of becoming a very good painter providing he didn't succumb to the forces that would make him an art world mascot." Judging the collaboration, Raynor said that Warhol had scored a TKO over Basquiat. Since Basquiat did most of the work on this collaboration and Basquiat was from Brooklyn, using Raynor's boxing metaphor, she might be guilty of a Manhattan hometown decision. Basquiat was not the only one who accused Warhol of taking credit for work that wasn't his.

Lynn Goldsmith was successful in winning a lawsuit against Warhol on appeal in March 2021, after the Second Circuit Court of Appeals reversed a 2019 ruling from New York's Federal Court finding that Andy Warhol had made fair use of Goldsmith's 1981 photograph of Prince when he created the "Prince Series." Goldsmith appealed that verdict, arguing that the Warhol artworks were not a transformative use of her image. "We agree," Judge Gerard E. Lynch wrote. "The 'Prince Series' works are substantially similar to the Goldsmith photograph as a matter of law." The Supreme Court agreed with the Second Circuit in a 7-2 count.

Those who posed as Basquiat's friends exploited him in a different way. Filmmaker Jim Jarmusch explained why he refused to see Julian Schnabel's film about Basquiat: (*Reading from clipboard.*)

"I knew Jean-Michel, and he was not friends with Julian. I like Julian very much, he's a very generous guy, even if he is an egotistical character. I refused to talk to Schnabel about Jean-Michel when he was making the film. But Jean-Michel was not a fan of Schnabel as a person back then. And I would not betray him in that way."

GRACE: Basquiat's female companion, Paige Powell, says that Basquiat ridiculed Schnabel's work. In the Schnabel film, Paige Powell is depicted as an innocent who martyred herself on behalf of a crazy unreliable, so unreliable that he stood up Mary Boone who was receiving a fifty percent commission on each painting she sold. In her own account, Paige Powell said that she was right there with Basquiat doing cocaine and heroin.

RAKSHA: Andy Warhol dismissed Schnabel as pushy, a bad painter, who visits other people's studios to see what he can copy. Warhol got a lot of laughs when he related that Schnabel stood before his paintings and explained to everybody what they meant. Schnabel's film, *Basquiat*, should have been called *The Schnabel Home Movie*. It shows that those who pretended to admire him could be just as insensitive about the painter as Kramer, Rayner, and Hughes.

Schnabel, who boasted that he was as close to Picasso as we're likely to get, becomes Basquiat in a twisted way. Since Basquiat's father didn't grant him permission to use the originals in the film, Schnabel painted Basquiat imitations. Schnabel's own paintings appear in the film as much as his Basquiat imitations. He's all over the place, including contributing to a song in a soundtrack marred by White men straining to sound like Negroes. All of Schnabel's interests are brought to bear in *Basquiat*.

Rayner wrote: (*Reads from clipboard.*) "The baronial interior of his current home appears as Albert Milo's domicile. There are cameos by his parents, his daughters, and his second wife, most of them as Milo's relatives. And while Schnabel doesn't actually appear in the movie himself, the scene of Basquiat and Warhol's collaboration at the Factory has, as backdrop, several silk-screen paintings that depict Schnabel as a young, lean man, paintings that Warhol never made."

So Schnabel's producing and directing a film about Basquiat, given that Schnabel and Basquiat were rivals, is what it would have been like if Joe Frazier had produced and directed a film about Muhammad Ali. It shows. Basquiat is shown as a junkie stumbling around New York. Living in a cardboard box. Yet, Charleen Touchette says that he had jobs. A downtown Tribeca clubhouse movie, Schnabel's most telling scene comes when Basquiat enters Schnabel's home. Schnabel gives him an update about his success, while Basquiat, his reputation as a hot painter on the decline, listens.

About five minutes is spent on Basquiat picking at a pimple. Basquiat draws a portrait of Schnabel's daughter. Milo picks it up and uses it to put Basquiat down, saying to her, "You're prettier than that." It's obvious to the viewer that Schnabel has a family. Basquiat doesn't. After the visit Basquiat urinates in Schnabel's stairwell, and in an interview with Charlie Rose, Schnabel describes this as Basquiat marking territory, a curious way of putting it because "scent-marking," in this case using the smell of urine to mark territory, is what animals do. Reminds me of the scene in *Critical Condition*, a film starring Richard Pryor during his decline. In one scene, Pryor plays a dog who urinates on a man's leg.

GRACE: Throughout the Schnabel film, surfers are shown. Couldn't part of the budget have been spent on showing a scene in Hawaii? Because before returning to New York, Basquiat was drug-free while living there. He said, "New York is killing me." (*Reads from clipboard.*) Warhol returned to his religious origins after being shot by Valerie Solanas.

Sound cue out: "Barrelhouse Basquiat."

At the time of his death, a painting of Jesus Christ covered an entire wall of his studio. The Greek Byzantine church is gravely serious about icons. For this church, icons are windows on heaven. Was the shooting a warning from God that Warhol had substituted the icons of capitalism for those of saints? And why the images having to do with travel? Mobil Oil's Pegasus, Pontiac's, and Mercedes's logos, are they all having to do with Warhol subconsciously realizing the distance he'd traveled from the church? Were these saints of capitalism false idols? Substitutions for the real saints? And that by inserting a motorcycle in Warhol's take on Leonardo da Vinci's *Last Supper* was Warhol giving a sign that he had returned home? Or was the sexually ambiguous individual sitting next to Jesus, the image that got his attention? Warhol was attracted to sexual ambiguity. Or was it the eel that appears on the menu? The eel totem fits Warhol. Deceptive. Mistaken for a snake, it is actually a fish. A surrealist gag. One that poet Ted Joans would like. The eel has expensive tastes. Like the eel prefers trout and doesn't settle for rock cod. But like Duchamp and his follower Warhol, the eel is a scavenger. Profiting from the ideas of others. Plagiarizing.

Basquiat once served eel to a group of art dealers. With the lunch was he making a point? That he was being scavenged. He said

that art dealers had pimped him. Was Warhol's painting the Virgin and Child a way of asking forgiveness for substituting Marilyn Monroe for the Madonna? Around the Factory, Warhol was called the Pope, Father. He was given church monikers.

RAKSHA: Basquiat was not the only Black genius encouraged to do drugs in order to increase production. It's like if one would inject a horse with Lasix to improve its performance. Capitalism was greedy for speedy production from artists whose patrons were no longer royalty and the church, but streamers, Spotify, Apple, Amazon. They were under pressure to create new work for sold-out concert tours. For Wall Street, art was just another commodity that had to be sold, a trend that began in 1904. This required artists like Basquiat, Michael Jackson, Prince, and others to go without sleep and depend upon stimulants to stay awake so that they could meet demand. So the muse had evolved from the dainty figure from the Victorian era to a figure who would kick your ass.

Projection in: 1: Victorian Muse; 2: Amanda Nunez.

Pummel you with blows of creativity that kept you up nights, so as not to miss a note, a lyric, or a deadline.

Projection out: 1: Victorian Muse; 2: Amanda Nunez.

Sound cue: RAKSHA's phone rings. She takes the call.

RAKSHA: Yes. Okay. Right.

GRACE: Who was that?

RAKSHA: Van Helsing. She wants to see me. Wants to know how much progress we're making. I got to go. (*Exits.*)

GRACE: (*To* RAKSHA *as she exits.*) She'll put us on a deadline. I'd better work on my notes. Let's see. (*Reads from clipboard.*) One of his girlfriends was able to tell which drug influenced which painting. Whether it was cocaine or heroin. He turned to heroin after cocaine use, created a hole in his nose. Except for Paige, nobody seemed to care, as long as he was producing art from which others benefitted.

And so, when Basquiat was broke, he sold his body for $10 dollars a pop. In the end, did he sell his soul? He was no longer the enfant terrible who would sell a postcard for 65¢ to purchase a package of cigarettes, which would be resold by the buyer for $1,000. Warhol said that at one point Basquiat played for the market. Most of the White critics regarded Basquiat as a graffiti artist who benefitted from his relationship with Warhol. He resented the title. He said that his friends who were formerly called graffiti artists, like Keith Haring, were no longer called that by critics. Others say that Basquiat resurrected Warhol. Basquiat got Warhol to paint again, which he had abandoned twenty years before their meeting. Now, Warhol's mascot's work is worth more than Warhol's. Basquiat's *Untitled* (1982), ranks at number ten among the highest amounts paid for a painting, selling for $110.5 million Warhol's *Double Diatribe* (1963), comes in at number twelve, $105.4 million. Maybe jealousy is the reason Basquiat was feared and hated.

He's still hated. An execrable graphic novel by Julian Voloj and Søren Mosdal, called *Basquiat*, shows that the hatred of Basquiat hasn't subsided. Published in 2019, thirty-one years after his

death, from the first page, which shows Basquiat in his shorts laying on a bed surrounded by drug paraphernalia—

Projection in: # 1 from graphic novel.

—to the last page which shows that same view, Basquiat is shown as a violent, crazed, angry individual who is so hard to handle that he drives his mother to a mental institution. A thief who robs elderly White women and abuses his White lovers.

Projection #1 change to: #2 from graphic novel.

Only when he snorts coke does he become a monster and is able to paint. While the facial expressions of Whites are calm, Basquiat is shown throwing tantrums and his eyes bulging.

Projection #2 change to: #3 from graphic novel.

Very little about his art. The preponderance of the drawings show undressed White women with Basquiat getting high.

Projection #3 change to: #4 from graphic novel.

He's even shown handcuffed to a bed presided over by a dominatrix. Like the imperialist who shat on a Haitian flag, Voloj and Mosdal substitute their own art for Basquiat's.

Projection out: #4 from graphic novel.

You don't have to be a Black genius to reach a bad end in the world of art. Look at the White artists who died of overdoses, suicide, in poverty. There must have been some place where Basquiat

found peace, a refuge from art dealers, buyers, and the Warhol death cult. My research has found that Hawaii was a place where he could escape the pressure. Basquiat traveled to Hawaii one last time. During his last night on the island, he dreamed about Richard Pryor. Basquiat and Pryor had met in Los Angeles. Fred Hoffman had arranged for Basquiat to paint Richard Pryor's portrait. It was after Pryor's accident that occurred during an episode of freebasing. There was no portrait as a consequence, but Pryor telling Basquiat that he had bought the film rights to the Charlie Parker story, another genius murdered by New York, inspired Basquiat to do a spate of drawings about the saxophonist.

Light cues: Spot out on FORENSIC EXPERTS *and fade up on the* BARON's *library.*

ACT 2, SCENE 3

The BARON *is preparing to leave the library. Puts on his cape, a beret, and white gloves and is about to exit when* DETECTIVE MARY VAN HELSING *enters. She wears a headscarf wrapped in a Caribbean style and carries a bucket filled with cleaning supplies and the* New York Times, *which she uses to help hide her face as she quietly moves about the library, pretending to be engrossed in her "dusting."*

BARON: (*Startled.*) Who are you?

MARY VAN HELSING: (*Speaking with a fake Caribbean accent.*) I'm the new cleaning lady.

BARON: It's one o'clock in the morning. Aren't you supposed to come during the day?

MARY VAN HELSING: I'm working the night shift. I thought that the employment agency told you.

BARON: Very well. But don't throw anything out, and don't enter the basement. Now if you will excuse me, I have errands.

BARON *exits with possible shadow screen cross as* DETECTIVE MARY VAN HELSING *is distracted by trying to figure out where* JENNIFER BLUE *might be hidden.*

MARY VAN HELSING: (*To audience.*) Now let me find out what he's hiding in the basement.

Sound cue: DETECTIVE MARY VAN HELSING *disappears offstage. We hear her footsteps going downstairs and then two people's footsteps coming upstairs.* DETECTIVE MARY VAN HELSING *returns with a very weak* JENNIFER BLUE.

JENNIFER BLUE: But he told me that he loved me and that I could live forever.

MARY VAN HELSING: (*To audience.*) Dumb bitch. That man don't love no one but himself. (*To* JENNIFER.) What did they teach you at Bard?

JENNIFER BLUE: But he left two punctures on my neck. He says that in Bavaria this is a sign of affection.

MARY VAN HELSING: He had you down there sleeping in a coffin. Didn't you think that was odd?

JENNIFER BLUE: He said he and I were rehearsing for a performance piece. (JENNIFER *faints.*)

Sound cue: DETECTIVE MARY VAN HELSING *dials 911; Hears operator ask: "911, what's your emergency?"*

MARY VAN HELSING: Better get an ambulance over here. Got a girl here. She's lost a lot of blood.

YOUNG BLOOD *appears, still in bikini and cowboy hat. Dazed. Sleepy.*

YOUNG BLOOD: Where's the Baron?

MARY VAN HELSING: Boy. Go put some clothes on. What's wrong with you? (DETECTIVE MARY VAN HELSING *pushes* YOUNG BLOOD *off the stage. Two* PARAMEDICS *enter and carry* JENNIFER BLUE *out on a stretcher.*)

DETECTIVE MARY VAN HELSING *speaks to the* PARAMEDICS.

MARY VAN HELSING: My blood type is O if you need some. (*Now speaks to herself.*) Boy, this art world is not like it used to be. We sure have come a long way from Jacob Lawrence and Charles White and Margaret Keane, my favorite, whose husband was another one of these plagiarists. You see today's paper? A Dutch museum paid an artist $83,000 for a painting. He returned a blank canvas that had the words…(*breaks into laughter and momentarily can't continue*)…that had the words…(*breaks into laughter again*)…"Take the money and run." (YOUNG BLOOD *returns with more clothes on.*)

MARY VAN HELSING: That's more like it. Why didn't you show up for the show, which featured your collaboration?

YOUNG BLOOD: He locked me in. He said that nobody had ever heard of me and that he was the one who was important. They had me working twenty-four hours turning out paintings. They gave me cocaine to keep me awake. They kept feeding me some black stuff, tiny fish eggs or something. I need to go to Taco Bell.

MARY VAN HELSING: (*Laughs.*) Looks to me like you did all of the collaborating.

YOUNG BLOOD: He'd put some famous logo in a painting, like GM for General Motors, then ordered me to do the rest and then he

would disappear and come home shortly before dawn.

Sound cue: Key heard turning in the lock.

YOUNG BLOOD: That's him now. What's taking him so long?

MARY VAN HELSING: (*Slowly, dramatically.*) I had the locks changed.

Sound cue: BARON *shouts and bangs on the door are heard from offstage.*

Light cue: Sun comes up, continues to get brighter as the BARON *gets more frantic.*

BARON: Let me in!!! Open the door!

YOUNG BLOOD *goes to open door.*

MARY VAN HELSING: (*Sternly.*) Don't you open that door. Go get your things. I'm taking you out of here.

BARON: (*Voice continues to be heard from offstage.*) Open the door. Somebody open the door!!! I'm locked out! Help!

YOUNG BLOOD: But... But...

MARY VAN HELSING: You heard me! You stand right where you are. As I always say, sunlight is the best disinfectant.

YOUNG BLOOD: But he's my mentor.

BARON's *screams still heard from offstage.*

MARY VAN HELSING: Boy if you dare open that door I'll smack your face! (YOUNG BLOOD *retreats. Goes to get his backpack and hat.*)

Puffs of smoke from an offstage smoke machine and/or a pile of powder seeping out from the wing are seen as the BARON's *screams and shouts from offstage become silent.*

Sound cue: Loud knocking.

DETECTIVE MARY VAN HELSING *opens the door to see* AGENT ANTONIO WOLFE *standing there.*

MARY VAN HELSING: Well if it isn't Mr. Antonio Wolfe.

AGENT WOLFE: Where's the Baron?

MARY VAN HELSING: You're standing in him.

DETECTIVE MARY VAN HELSING *shuts the door behind* AGENT ANTONIO WOLFE, *whose footsteps are heard as he runs and gives out a wolf howl.*

Light cue: Shadow screen up: AGENT WOLFE *appears in shadow, running away, his face transformed into that of a wolf. Shadow screen lights out once* WOLFE *has disappeared.*

MARY VAN HELSING: (*Does not appear to notice* WOLFE's *shadow.*) He took off.

DETECTIVE MARY VAN HELSING *leads* YOUNG BLOOD *by the hand to exit.*

MARY VAN HELSING: Now step over that pile of dust outside the door respectfully. After all, it was once a Baron.

ACT 2, SCENE 4

Voice offstage: Basquiat dreams of Richard Pryor.

Light cue: In shadow, we see a horizontal sleeping figure (Basquiat) and an upright moving figure (Pryor).

Sound cue: "Hands of Grace" up.

RICHARD PRYOR: (*In voiceover.*) Jean, Richard here. I can see why you would want to sojourn in Hawaii. I had a house there. In Maui. I'd go there to get away. Get away from people like NBC censoring me. People leaning on me to give them money. Pay their way. Women pestering me. One of them said she was pregnant by me. I had to pay her $600,000. This woman Jennifer made me beat her up, then she had the nerve to sue me. She made me shoot up that car. Then there was Hollywood depriving me of roles like the one I wanted in *Blazing Saddles*. They chose Cleavon Little. All the shitty movies they had me do.

Projection in: Pryor #1.

I'll admit it. Like the one that came out last year, *Critical Condition*. The critic Janet Maslin said that I looked haggard and agitated in that film. She was on to something. That's because I was shoveling all that White Lady up my nose. That's why I look all shriveled up. The *Washington Post* said I looked "emaciated." And the makeup couldn't hide where they had to graft my skin. The producer came into my trailer and started cussing at me. Hurting my feelings. He said, "Richard, we're

losing all of this money doing takes because you come in here so high that you don't remember your lines and then you take all of these coke breaks. Our budget has tripled because of you. Now if you Black actors can't get it together, we're going to have to bring in some backups. Some African and British actors. They're disciplined. They studied at the Royal Academy. And they won't make demands because they are glad to be here. And unlike you, they don't come to the set brandishing weapons. Like when you chased that producer. Just because he suggested that you play the fairy godmother in *Cinderella*. Compare that to the Nigerian actress who said that she's so happy to be in America. When she goes to the grocery store, she has a choice between a variety of things that she can't buy in Africa. When she walks down the aisles where the cereals are displayed, she sees so many brands to choose from that she bursts into tears of happiness. Unlike you pushy Black Americans, they are innocent. One of them placed teaspoons of cocaine in her tea. She thought that it was sugar. You told us to kiss your rich Black ass. Well before it's all over, Richard, you might be kissing our rich White ass. With these well-mannered Nigerians on the scene now, your kind can always be replaced."

That warning didn't change my attitude. You'd think that I would have learned my lesson when I caught on fire while freebasing. I was on fire like one of these Buddhist monks. Jennifer made me do that. I've gotten sucked in by the Hollywood wall-to-wall sex. It's like I'm on a planet called Vagina, and I'm the only inhabitant, exploring every nook and cranny, like I'm one of them moon rovers. But I never blew a hole in my nose like you did. Both me and you wanted to make it to the big time. Like I told Ishmael Reed, I wanted to get over.

Projection in: Change from Pryor #1 to Pryor #2.

There was that time in Berkeley. Early '70s. You might call that my graffiti period. It was my most creative period. While you were scribbling graffiti on the walls of the Lower East Side, I was speaking graffiti at small clubs in Berkeley and San Francisco. The happiest period of my life. I hung out with Cecil Brown, Ishmael Reed, Claude Brown, and activists like Huey Newton. Reed and Brown told me that I couldn't bring my corny Las Vegas routine to Berkeley where they were into a brutal cutting-edge comic aggression. I was free from restrictions. But like you, I wasn't satisfied doing small clubs, honing my craft. So, I abandoned that scene. Hollywood put restrictions on my art. They gave me so much money, I couldn't refuse. You fell into the clutches of Andy Warhol and his cult. He not only signed his name on supermarket products, but he signed his name on his workers because they were no different from the inanimate objects to him. He signed his name on your ass. Like someone would brand a motherfucking cow. He took advantage of you, Jean, like you was his toy like that movie where I played the White man's toy, one of the many shitty movies they made me do. All of these dopey scripts they put in front of me.

Projection in: Change from Pryor #2 to Pryor #3.

How did I deal with this fame? A straight-jacketed fame? These producers told me where I could eat and where I could even take a shit. I did like you. Snorted mountains of White Lady. Like you I started moving with the caviar crowd. Don't be like me Jean. Stay away from White Lady who made me her slave. Made me set myself on fire. Fucked up my health. Hollywood is killing me.

Projection out: Pryor #3.

Don't let New York kill you. Those people have gotten everything out of you. Sucked you dry. Go to the home of your father's ancestors. Jean-Michel. It's too late for me. But not for you.

Sound cue: "Hands of Grace" out.

Lights cross-fade out on shadow screen with sleeping Basquiat, as moving Pryor figure exits the screen and fade up on FORENSIC EXPERTS.

ACT 2, SCENE 5

GRACE: What is Warhol's fascination with beautiful boys? In his films—and in his art—there are beautiful boys. It's like a cult. We can go to Hadrian again.

RAKSHA: Must we?

GRACE : That's where the cult of the beautiful boy begins. I've made some notes. (*Reads from clipboard.*) Imagine the scene.

Sound cue up: "When Beautiful Boys Drown in the Nile They Become Gods." Continues until completed.

Romans moving slowly up the Nile, the longest river in the world. Emperor Hadrian and his lover Antinoüs. Roman military brass, government officials. They pass the Pyramids, the statues of gods with animal heads. Crocodiles slide from embankments. Monkeys swing from banana trees. Hippos rest in the mud. Lizards stand frozen in the sand. Egyptians are in town, preparing for the festival of Osiris. It's October. The year is 130. Hadrian lies in bed with his teenage lover Antinoüs. The night before there was much festivity. Members of the flotilla danced to an Egyptian orchestra and Hadrian and Antinoüs lay on pillows and alternately drank wine while nude young men and women danced before them. Antinoüs was the most beautiful boy in the Western ancient world. He was a Turk who traveled with the Emperor throughout the empire. Hadrian would kill a lion for the love of this boy, but then in the year 130, an event occurred from which the emperor would never

recover. The boat had anchored by a temple dedicated to Thoth, the Egyptian god of writing. Suffering from a hangover, the boy got up to go to the bathroom and as he began to enter the room, which one reached by leaving the cabin and walking along the side of the boat, unsteadily, he was pushed or stumbled over the side. Hadrian, this conqueror, the most powerful man in the empire, broke down and cried when informed of the death of his beautiful boy. He could not be consoled. That night Hadrian saw a star that arose from the spot where they found his body. He named the star after his lover. Antinoüs became the original superstar.

Projection in: Beautiful Boys, Basquiat and Antinoüs.

But there was another darker version of what happened. As Basquiat, the radiant child of the downtown art scene of the 1980s, was sacrificed to sustain the dying career of a fading super star, Antinoüs was sacrificed so that Hadrian would recover from a mysterious illness. Following the beliefs of the local priests, all beautiful boys who drown in the Nile become gods. Did Hadrian go overboard to express his grief? Deifying his beautiful boy? Twenty-eight temples were dedicated to him. Like Basquiat of the 2000s, statues of Antinoüs appeared throughout the empire. His face appeared on coins, and on plates. After his death, Basquiat's image appeared on coffee cups, T-shirts, shoes, socks, canteens, shopping bags, etc. Like Antinoüs and Osiris, both linked by priests because both drowned in the Nile, everybody wanted a piece of Basquiat. Bits of him proliferated like the dismembered god Osiris. Osiris was chopped up into fourteen pieces by his assassins so that he couldn't be recovered. All three—Osiris, Antinoüs, and Basquiat—drowned. The first two drowned in the Nile. Basquiat drowned in his vomit.

Projection out: Beautiful Boys, Basquiat and Antinoüs.

RAKSHA: Once again, Grace, you're wandering way far afield with these analogies to the classics.

GRACE: I don't think so. A number of Basquiat's paintings include body parts. For example, Basquiat's *Kings of Egypt* shows body fragments: teeth, torso, and head. They chopped up Osiris's body. And what are we to make of a painting he left us with? It's called *Nile*. Was Isis's reassembling of her husband/brother similar to the revival of Basquiat? Has Basquiat become the beautiful boy of the 2000s? Reincarnated as himself?

Projection in: Veve of Baron Samedi.

> If Basquiat was not acquainted with Osiris, he was certainly familiar with Baron Samedi, a Haitian loa who is a mythological descendant of Osiris. *The Guilt of Gold Teeth*, a fourteen-foot-wide work, which Basquiat painted when he was twenty-two, sold on November 9, 2021, for $40 million. It includes Baron Samedi, whose Yoruba antecedent is Iku. The painting was done in 1982. Osiris and Baron Samedi both preside over the dead.

Projection out: Veve of Baron Samedi.

Projection in: Veve of Bridget, the Baron's wife.

> And maybe he was familiar with the redhead, The Mother of the Dead, the Irish loa? The Baron's wife who rejected advances from the son of Dracula.

Projection out: Veve of Bridget, the Baron's wife.

But like Antinoüs, some regarded him as a demon. A trickster. He was a demon to the principal whose face Basquiat used as a target for a cream pie. Was his father attempting to get rid of the demon in Basquiat when he stabbed him? Warhol is supposed to have told Gerald Malanga that he imagined himself as the keeper of a male brothel, tending the register "in a large dormitory with rows of beds without partitions between them. People would come in and have sex with a boy in a bed and then pay Andy the money on their way out." Could it be said that Warhol sold parts of Basquiat's soul? Was Basquiat sacrificed by those who chose profits over his well-being? Basquiat was the most beautiful of the beautiful boys and though many women loved him he was a virgin thrown into the midst of the damned.

RAKSHA: John Giorno exposes the dark side of the Warhol legend in his book *Great Demon Kings: A Memoir of Poetry, Sex, Art, Death, and Enlightenment*. Commenting, Giorno's fellow Buddhist Genny Lim described the Warhol culture as "predatory and decadent." Few escaped this decadence. One who did was Ultra Violet. (*Reads from clipboard*.) She writes: "Yes, I have gone through many dangers, tolls, and snares. I have been brought safe, I feel, to tell this story. To tell about the psychological and sociological devastation, the errant activities, the public sex, the hedonism in excelsis, the anything goes films in which the performers were stoned on drugs. Then, to make it worse, we exposed our exploits before young students and encouraged them to get as stoned as our performers. Even though for me sexual immortality was but the despairing side of the search for emotional security, I have to acknowledge that I participated in a movement that helped lay the basis for the explosion of hardcore pornography, drug pestilence, and the AIDS plague. Most of us have paid a heavy price, some with our lives, some with our

health, others with years squandered. I feel I was luckier than most, for the '70s, when death brushed me, I repented and found my way to inner peace."

GRACE: Basquiat was an innocent among the vile who had prostituted themselves and craved new blood. The leeches got fat bleeding him and bleeding him until there was no more blood to bleed. He could bleed no more. He thought an artistic family would substitute for his mother and father. Everybody whose mother has left them knows the feeling. His father kicked him out and so he ended up in the Village.

What would have happened if he had traveled to Haiti from Hawaii instead of returning to New York to die? Suppose that Richard's intervention, coming in the form of a dream, had actually happened. Instead of returning to his killer, New York, to be finished off, Basquiat took Richard of the dream's advice. Suppose that in 1988, he left Maui and went to the land of his father's ancestors. Haiti. The city of Jacmel. A city surrounded by blue pools fed by waterfalls. A scene of lush vegetation. Where Raymond les Bains is a popular beach. Suppose that he would have restored an abandoned chateau built in the 1700s. That once a week he would go into town to buy groceries and a bottle of rum. Make papier-mâché masks for Carnival. Sometimes joining the Carnival. No art dealers, patrons, buyers, critics to bother him. To work him to death. Instead, admiring townspeople would be very respectful of his privacy. He would have survived. He would be sixty-one years old.

RAKSHA: Instead, Basquiat returned to New York, the graveyard for Black geniuses. Lee Morgan, murdered at Slugs. Charlie Parker overdosed. Bob Thompson, dead at twenty-eight. Was

Basquiat a victim of foul play? The critics, the museums, jealous rivals, members of the Warhol circle, the women groupies who pampered him and joined him in his self-destruction, unscrupulous art dealers? You don't have to use a weapon to be guilty of foul play. (*Pause.*)

GRACE: Are you ready to submit our report to Detective Van Helsing?

RAKSHA: I think we have enough.

Curtain.

Sound cue up: "Tolls for Basquiat" as light cue: stage lighst out, followed by bow. Lights up.

AFTERWORD

In writing about the racist history of cocaine, the editorial staff of the American Addiction Centers reported on March 15, 2012, that forcing cocaine use on Black slaves and workers increased production. Those who leeched off of Jean-Michel Basquiat didn't force cocaine on him, but as long as his feverish production lined their pockets, they looked the other way while he slowly killed himself. A visitor to the "dungeon," provided by a gallery owner, said that Basquiat was treated like a slave, and there was coke everywhere. The gallery owner disputes this. Even though some of his contemporaries, like Andy Warhol, were regular drug users, this is the image of Basquiat that has been promoted by writers and members of the cult led by a man whom filmmaker Emile de Antonio called "The Angel of Death's Apprentice." Barely out of his teens, Basquiat was thrust into the New York art scene like a deer stepping into a cesspool of piranhas.

—Ishmael Reed

MORE FROM ARCHWAY EDITIONs

Archway Editions can be found at your local bookstore
or ordered directly through Simon & Schuster

QUESTIONS? COMMENTS? CONCERNS? SEND CORRESPONDENCE TO:

Archway Editions
c/o powerHouse Books
220 36th St., Building #2
Brooklyn, NY 11232